years of
bauhaus

KLASSIK
STIFTUNG
WEIMAR

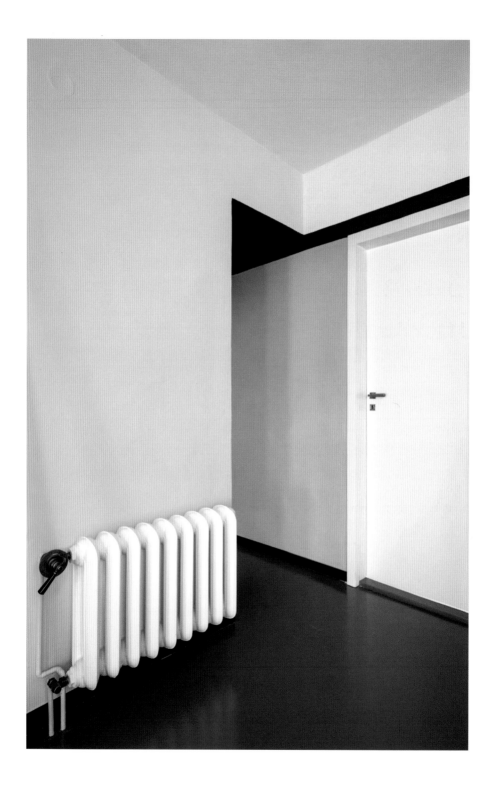

HAUS AM HORN

Bauhaus Architecture in Weimar

Edited by
Anke Blümm and Martina Ullrich

With texts by
Ute Ackermann, Anke Blümm and Martina Ullrich

HIRMER

KLASSIK STIFTUNG WEIMAR

CONTENTS

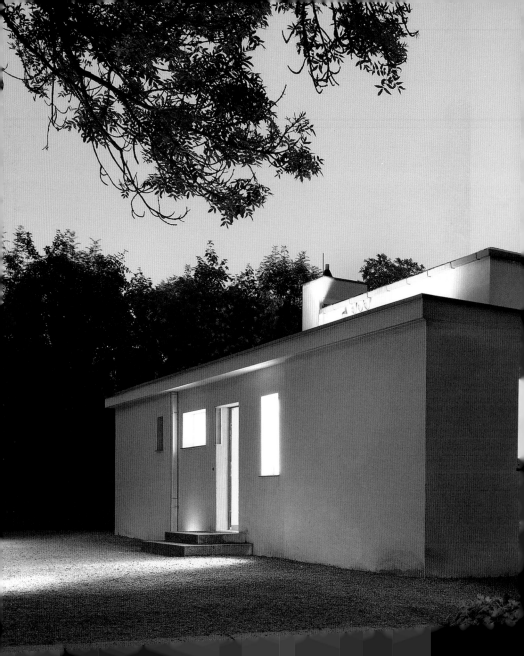

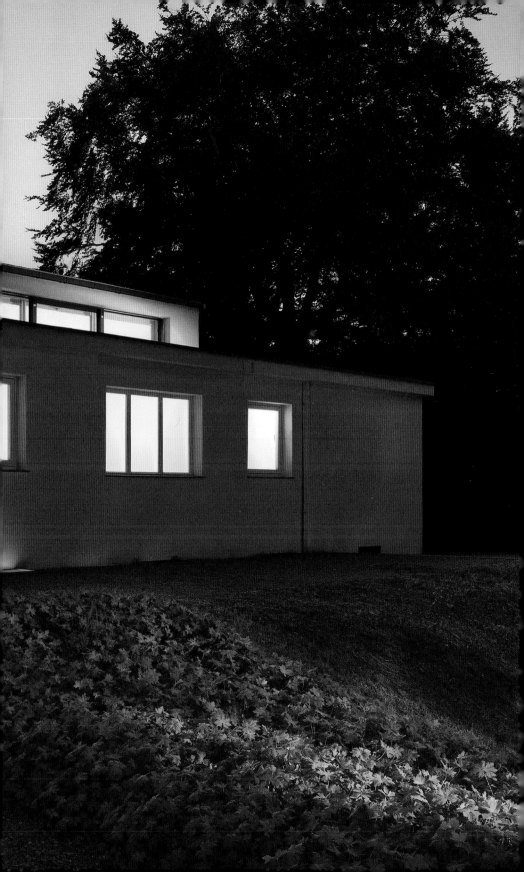

Over 20 years ago now the Freundeskreis der Bauhaus-Universität Weimar e. V. (Friends' association of the Bauhaus University Weimar) took over the custodianship of the Haus Am Horn in close cooperation with the Bauhaus-Universität Weimar. In the years that followed, starting in 1999, the association went to the utmost lengths in its endeavour to preserve the building. It organised more than 60 exhibitions, held hundreds of cultural events, academic symposia and lectures, oversaw the building's upkeep and ensured that it remain accessible to the public. Along with the Bauhaus-Universität and other partnerships, the Klassik Stiftung Weimar took regular turns as a partner in the association's programme of exhibitions and events. Many of the city's residents and students of the Bauhaus University from all over the world, moreover, will also recall the annual summer festivals that took up the festival culture of the Bauhaus.

In order to safeguard the future and the upkeep of the property in perpetuity, the Haus Am Horn was transferred into the ownership of the Klassik Stiftung Weimar at the beginning of 2019; together with the new Bauhaus Museum Weimar, the Neue Museum, the Haus Hohe Pappeln, the Liszt-Haus and the Nietzsche-Archiv, it is now among the Klassik Stiftung museums addressing the subject of 'Bauhaus and modernism'. The concept of the newly constructed Bauhaus Museum was therefore developed to link closely with the Haus Am Horn. Particularly in the 'New Everyday Life' section of the exhibition, the interior design, furnishings and fittings of the house are featured as outstanding achievements of the Bauhaus in its Weimar years. Under the 'Weimar Cosmos' master plan coordinated by the Klassik Stiftung, visitors now have access to a unique portfolio of built heritage spanning the most diverse styles of home decor from

the eighteenth to the early twentieth century, which also encompasses the Goethe Residence and Gartenhaus, the Schiller Residence on Schillerstrasse, the Wittumspalais, Weimar's castles, and the Wieland Estate in Ossmannstedt.

We are proud and grateful that as part of the Bauhaus centenary year this singular architectural testimony to Neues Bauen (New Building) at the Weimar Bauhaus can be reopened to the public with a new permanent exhibition that conveys the idea of the original presentation to visitors with the same immediacy as in 1923.

Wolfgang Holler

General Director of Museums
Klassik Stiftung Weimar

INTRODUCTION

ANKE BLÜMM

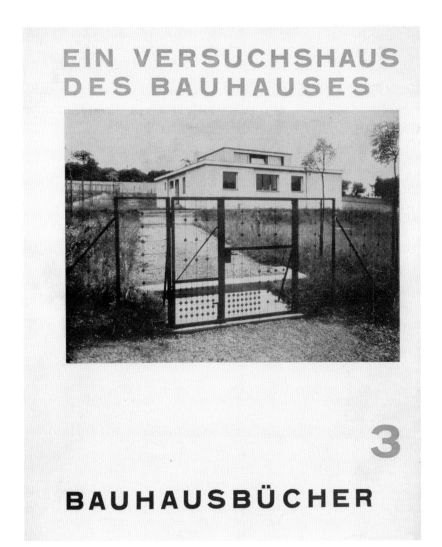

Cover, Adolf Meyer (ed.), *Ein Versuchshaus des Bauhauses in Weimar* (Munich, 1925).

THE HAUS AM HORN is the first and only work of architecture realised by the Staatliche Bauhaus Weimar (Weimar State Bauhaus). It was built in 1923 as an experimental house for the Bauhaus exhibition. The original design was by the Bauhaus master Georg Muche, while management of the construction work was entrusted to Adolf Meyer and Walter March from Walter Gropius's architecture office. The interiors were designed and realised by the Bauhaus workshops, which presented here for the first time how they imagined contemporary living. The building has been a UNESCO World Heritage Site since 1996.

Through this solitary building, envisaged as a prototype, the Bauhaus demonstrated its vision of community living and working in the future. Indeed, before the house was built, ideas had been bounced around since 1920 for a much larger Bauhaus housing estate, for which the Am Horn site was earmarked. The proposed scheme included residential homes, kitchen gardens, a school, children's play spaces and even public baths. All these plans were destined to stay on paper, however, because in 1925 the Bauhaus was forced to leave Weimar. Only at its new location, in Dessau, could further building projects be realised: the iconic Bauhaus Building, the Masters' Houses and, in the south of Dessau, the Dessau-Törten Housing Estate. Hence the experience of building the Haus Am Horn in Weimar was an important springboard for Bauhaus architecture in Dessau.

In a few years' time, in 2023, the Haus Am Horn will have stood for a hundred years. Its many different uses over the decades have left their traces on the building. While privately owned from 1924 to 1938, it was altered and expanded. In 1938 the building was bought by the Deutsche Arbeitsfront (DAF; German Labour Front), the Nazi

organisation that replaced trade unions. It belonged to the City of Weimar from 1951 and was lived in until 1998. At various times during the post-war years, up to three sets of tenants shared the house's 144 square metres of space.

The Freundeskreis der Bauhaus-Universität Weimar (Friends' association of the Bauhaus University Weimar) organised and oversaw the first major reconstruction and renovation, which was concluded in 1999. As part of these works, the structural modifications were removed, a first selection of built-in cupboards and lights were reconstructed and, similarly, the lost kitchen fittings were replaced in the original style. The Freundeskreis used the building for exhibitions and events for almost 20 years.

In the new exhibition, opening in 2019 to coincide with the Bauhaus centenary, the Klassik Stiftung Weimar, which has recently assumed ownership, is now making the house itself the main exhibit. It thereby honours not only the conservational demands of caring for the historic fabric of the building but also the growing interest of visitors from Germany and abroad in the house's architecture.

This short guide accompanies the opening of the new exhibition and presents a compendium of the diverse themes surrounding the house. A historical tour of the building describes the state of the house in 1923 and the ideas it conveyed. It also highlights aspects of the building's history, use, reception and renovation history, for the functionality and adaptability of the Haus Am Horn are part of its identity. Interviews with those involved in the new exhibition round off the book.

One of the challenges about the house is that immediately after the 1923 exhibition, all the movable furnishings were transferred to the financier Adolf Sommerfeld in Berlin. As a result, almost nothing has been preserved from the original fixtures and fittings. An important component in this short guide are thus the numerous historical exterior and interior photographs from 1923. They derive from the surviving Bauhaus albums, which are a treasure trove for Bauhaus research and now preserved at the Bauhaus-Universität Weimar. Another key publication for the short guide is a book by the Bauhaus itself: in 1925 the title *Ein Versuchshaus des Bauhauses in Weimar* (An

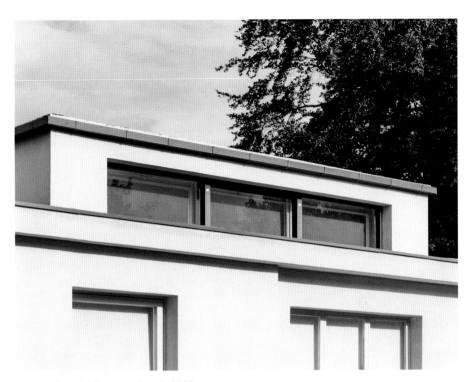

Exterior view with European beech, 2018

experimental house by the Bauhaus in Weimar) was published as the third volume in the series of *Bauhausbücher* (Bauhaus books). In addition to three essays by Walter Gropius, Georg Muche and Adolf Meyer, copious pictures and advertisements by the contracted firms reveal information about the construction process. From these extraordinary illustrated documents, the house's architectural history and the quality of its interior fittings can still be appreciated today.

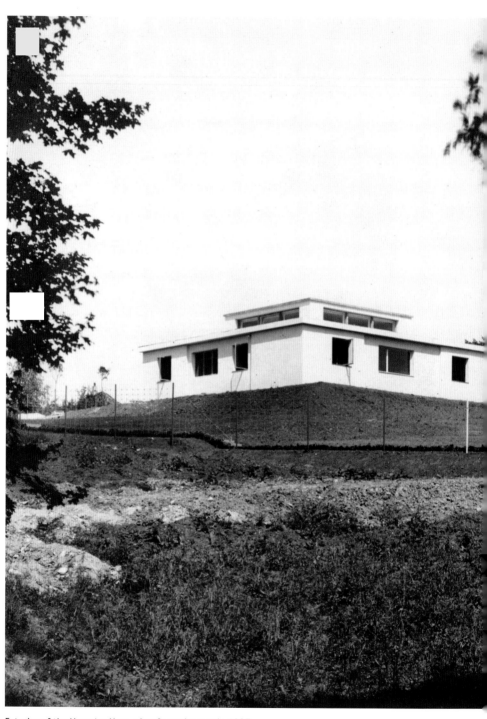

Exterior of the Haus Am Horn, view from the south, 1923

A HISTORICAL TOUR

ANKE BLÜMM, MARTINA ULLRICH

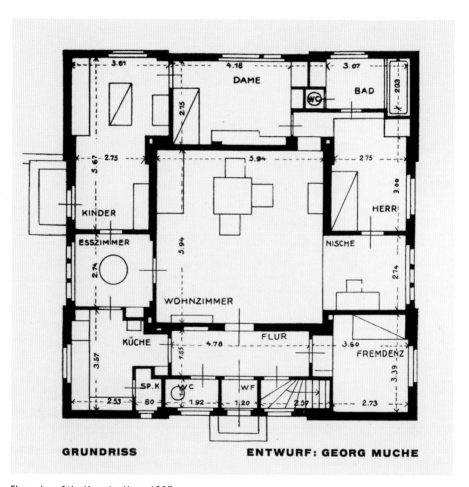

Floor plan of the Haus Am Horn, 1923

Approaching the site

Visitors who make their way up the steep path to the right of Johann Wolfgang von Goethe's Gartenhaus, on arriving at the top, may be momentarily disconcerted: where is the iconic building? Set on the back of the plot, the Haus Am Horn initially does not intrude on the view. Only if one follows the street Am Horn round to the right and stands at the intersection of Dichterweg and Eduard-Mörike-Strasse do two sides of the building make their imposing presence known. The house appears just as it did in 1923. But the European beech tree beside the house today was not part of the original 1923 stock of trees. Planted later, it is a harmonious complement to the white cube and has been left in place as a natural monument.

On noticing that the sides of the house are of equal length, it easy enough to deduce that its floor plan is square. Rising up from this is a central space which is likewise square with high strip windows along two sides. One further cube is characteristic of the house: a small chimney on the north-east side.

The design is accentuated by the emphasis on the four slightly protruding corners, while the central portion of each façade is somewhat recessed. But beyond this observation, the symmetry comes to an end. The windows are cut into the sides at irregular intervals, placing them in functional relation to the different rooms and sequences of spaces on the inside.

The site is enclosed by unpretentious black wire fencing. An entrance gate designed by the Bauhaus student Rudolf Baschant provides access to the grounds. The path leads to the north side of the house with its central entrance door, which is flanked by two

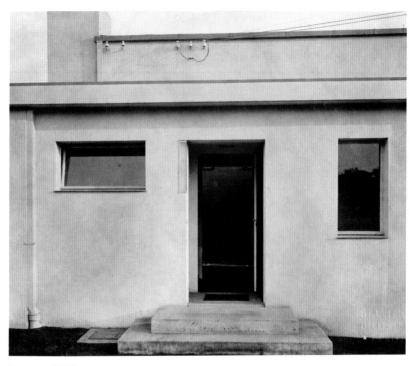

Entrance, 1923

smaller windows on the left and a larger one on the right. Another feature at the entrance is a door lamp whose cover is fitted flush with the corner of the house. ANKE BLÜMM

Entrance area and floor plan

Proceeding up two steps, the visitor walks in through a small vestibule before entering a laterally aligned hallway from which five doors lead off. This is the only specifically designated traffic area. Otherwise the house dispenses with hallways – by design. The dwelling was intended for a three- to four-person family without staff. It was meant to be low-cost, functional, and as space-saving as possible. This idea was resolved by means of the prominent central space, visible from the outside, which was intended as the main living area. Grouped

Entrance, 2019

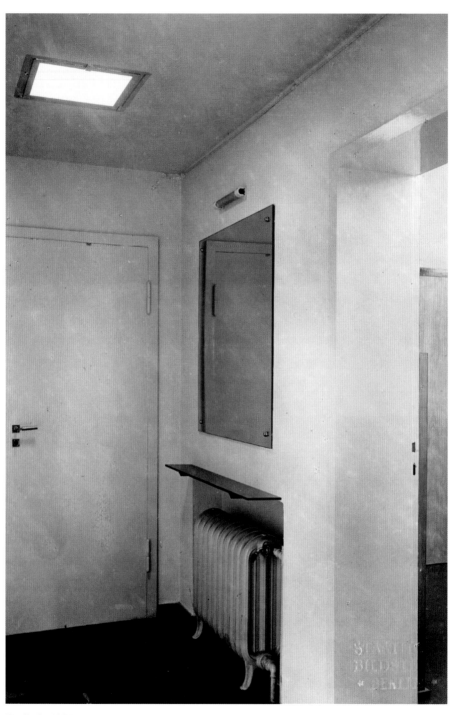

Vestibule, 1923

around it are the lower-ceilinged and much smaller functional rooms: the man's and the woman's bedrooms, the bathroom, the children's room, the dining room and the kitchen. The hallway gives access to a small lavatory on the left and, behind another door, a flight of stairs leading down to the basement.

On the right is a doorway into the guest room, the sole self-contained room in the house. To the left is the kitchen, so that the 'housewife' can bring her shopping or vegetables from the garden straight into the kitchen.

The hallway also accommodates a small broom cupboard, which served as a store room for cleaning equipment and may have housed the Vampyr vacuum cleaner supplied by the firm Santo. A large mirror with a shelf over the radiator was helpful for getting dressed and combing hair; it was lit by one of the tubular lamps (so-called *Soffittenleuchten*) designed by László Moholy-Nagy. Further lighting elements are two transparent skylights which allow natural light to fall into the hallway. The mirror and tubular lamps are reconstructions dating from the 1990s. ANKE BLÜMM

The central living room

On entering the living room, the visitor has now reached the centre of the house. The room, which has an area of 36 square metres and is four metres high, is illuminated from two sides with clerestory window strips. As today, the window frames were originally fitted with matt glass for the 1923 exhibition. One of the double windows can be tilted by means of a hinge mechanism. The other windows are side-hung and have knobs, known as 'olives', with which they can be swung open.

The eye-catching feature in the living room is the suite of furniture in the left corner, consisting of a table, three chairs, a sofa and a floor lamp. Originally a four-metre square carpet by Martha Erps occupied the floor. Its imaginative abstract design, consisting of multi-coloured squares, rectangles and stripes, echoed the diagonal circulation route through the house.

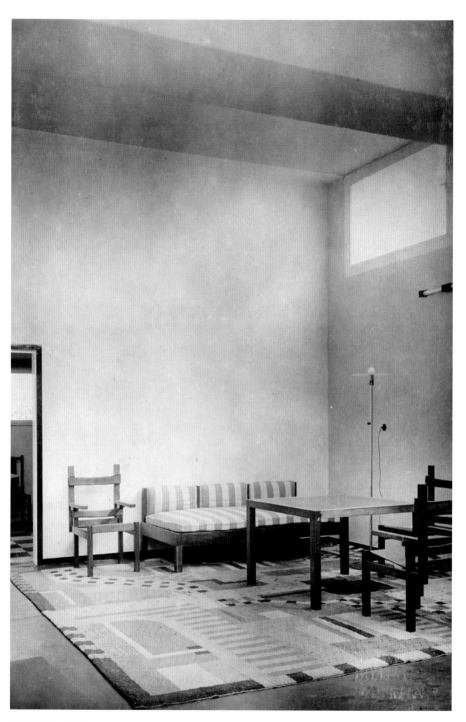

Living room, 1923

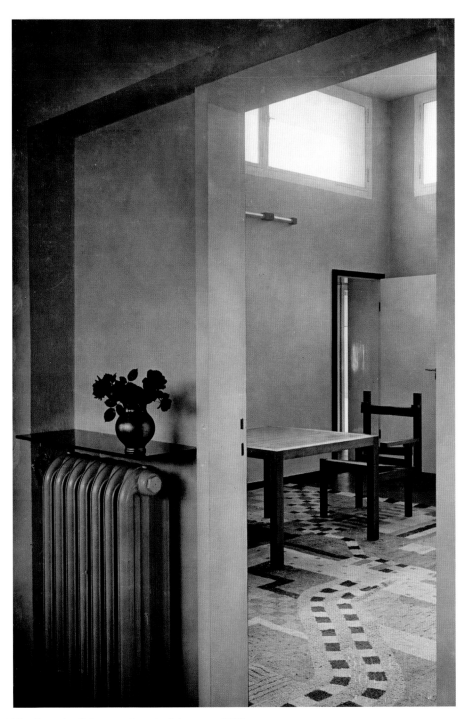

View from the dining room into the living room, 1923

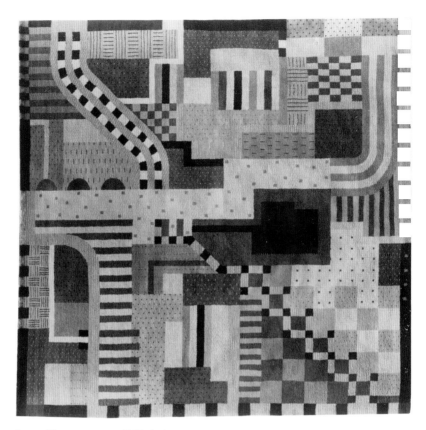

Knotted Smyrna carpet, 1923, design: Martha Erps

The sofa consisted of a wooden frame with a three-section backrest and was upholstered in a wide-striped fabric. Its designer is unknown, and the sofa has only survived in this photograph. In the new exhibition, the white outline furniture is positioned to indicate the space occupied by the sofa and the other lost furnishings.

The sofa suite furthermore included a table with three chairs designed by Marcel Breuer. Known as the *Lattenstuhl* (Slatted Chair), which consisted of wooden slats of varying lengths but identical width, the chair is one of the best-known objects from the workshops of the Weimar Bauhaus. The specific items made for the Haus Am Horn are probably lost, and those displayed here are reconstructions from the 1970s.

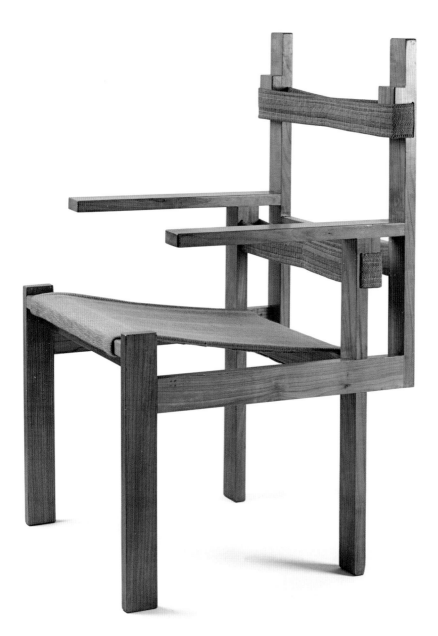

Lattenstuhl (Slatted Chair), 1922, design: Marcel Breuer

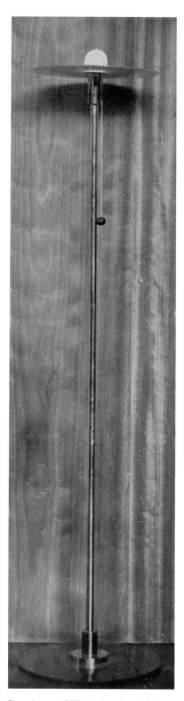

Floor lamp, 1923, design: Gyula Pap

Electric wall lighting was provided by two tubular lamps by László Moholy-Nagy. Black wooden blocks articulate the light fittings; these are reconstructions from 1999. Included in the ensemble was a floor lamp by Gyula Pap. The 1.60-metre-high lamp stood on a disc-shaped base, which in turn corresponds with an upper disc of matt glass on which the lighting element is centrally mounted. An upper pull cord is used to turn on the light. An original version has not survived, but the design has been reproduced under license since the 1980s; the item seen in the exhibition is a new edition from that source.

Also among the room's distinctive furniture was the living room cabinet by Marcel Breuer on the right side of the room. It has a rectangular footprint and is a stacked composition of wooden cuboids with different veneers: maple, padauk, Hungarian ash and pear. The most prominent feature is the square, tower-like mounted unit with glass shelves. This cabinet is one of the two items of furniture whose original parts from the Haus Am Horn have been rediscovered. In 2007, the architect Gerhard Oschmann augmented the parts to make a complete cabinet. The item shown in the house is a second complete reconstruction made by Oschmann in 2018–19.

Another furniture item by Breuer was placed on the left of the room, looking from the entrance. The wooden bookcase with the glazed side panels and four wooden shelves is now lost.

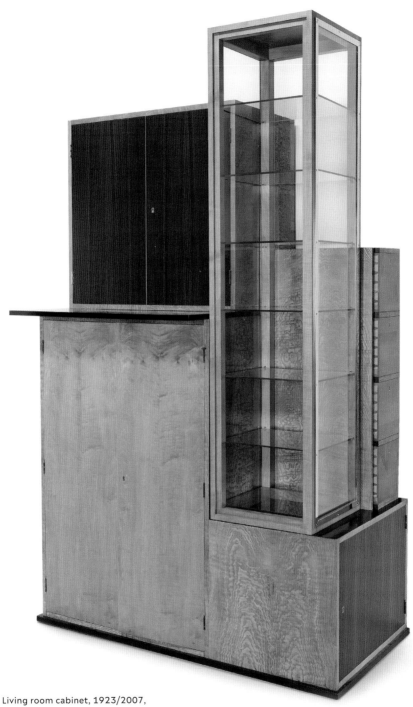

Living room cabinet, 1923/2007,
design: Marcel Breuer, partial reconstruction: Gerhard Oschmann

Book cabinet, 1923, design: Marcel Breuer

The wall painting is a work from the mural painting workshop, done by Alfred Arndt and Josef (Sepp) Maltan. Here, two colours are set against each other, an olive green and a light yellow. The lighter colour tone is carried across to the ceiling on the eastern side. ANKE BLÜMM

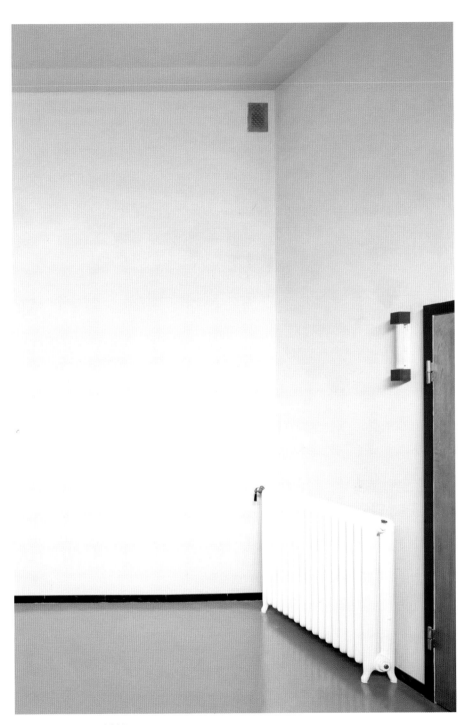

Ceiling, living room, 2019

Interior details

Other details of the interior decor and fittings catch the eye, and as these are continued throughout the house, they will be discussed at this juncture by way of example. First of all, attention is drawn to the doors. Some have black door frames which contrast with the wood-veneered doors. Other doorways are framed in white and have doors painted in glossy white oil paint. The handles are a design by Walter Gropius known as the *Gropius-Türdrücker* (Gropius lever handle). The door frames are also used in the bathroom, kitchen and lavatory as corner guards.

Another striking feature are the light switches. They were fitted with a white rotary switch and a transparent glass tile as a finger plate. They were reconstructed in 1999.

The radiators are three-part cast-iron issue, a standard industrial product of the 1920s. They are either wall-hung or floor-standing, and in some cases are not uniform in height. For the most part, they have black opaque glass plates fitted above them as covers. All the radiators in the house are new models, chosen to recreate the historical effect.

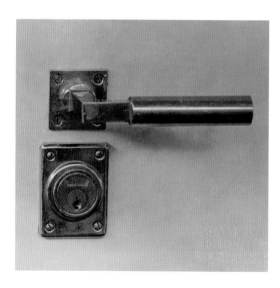

Door handle, nickel-plated bronze, 1922, design: Walter Gropius and Adolf Meyer

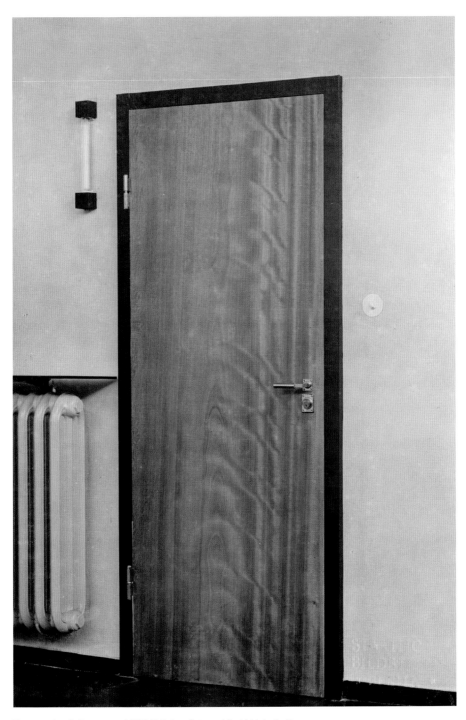

Door to the dining room, 1923, lighting fixture: László Moholy-Nagy

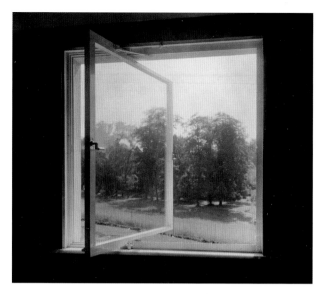

Vertical pivot
window, 1923

Opaque glass is an industrial product that was used in several places in the house and particularly for skirtings: these were either black, as in the living room, or white, as in the children's room. The sole exception was the guest room, where the architects opted for a red version. Some remnants of the original skirting material still existed and could be reinstalled and augmented, or else reconstructed.

The flooring material throughout the house – with the exception of two rooms – was Triolin. This served as a substitute material for linoleum. Because it was readily flammable, however, it never became a mainstream product.

Three types of windows were fitted in the house – vertical pivot windows, side-hung casement windows and, in the kitchen, a horizontal pivot window. These were surrounded with white wooden frames and fitted with single glazing. The design of the plain metal window knobs was also a Bauhaus original.

Some windows in the Haus Am Horn offered shading from the sun by means of blinds. These fittings, or reconstructions in some instances, have been reinstated at the windows and are concealed behind metal valances, now painted red just as they were originally. Only in the bathroom was this valance painted white. ANKE BLÜMM

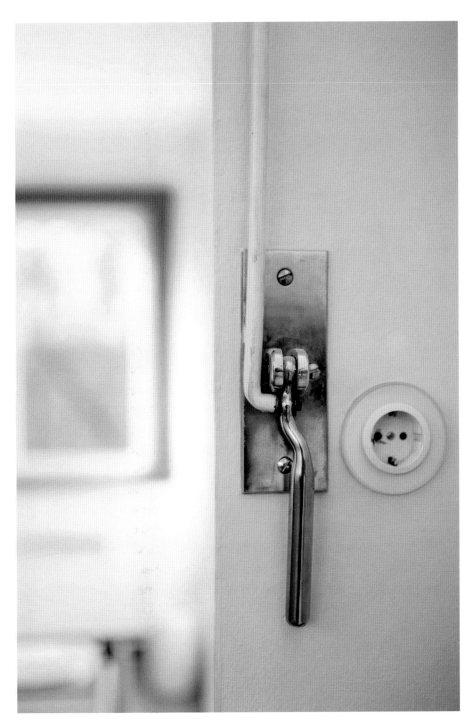

Window lever in main room, 2019

The work niche

Direct natural light falls into the central space through the three-part window in the work niche. The desk placed on this spot was a work by Marcel Breuer from 1923. The piece had drawers of three different sizes and two larger compartments. Its distinctive appearance derives from the contrasting use of lighter maple and darker cherry wood. The lighter wood structured the desk vertically and gave external emphasis to the internal drawer mechanism.

Matching the desk is a desk chair, also designed by Breuer, based on the *Lattenstuhl* (Slatted Chair) in the living room. It had no armrests, however; otherwise it would not have fitted under the desk. Unlike the chairs in the living room, this one had a striped seat cover. The model resembled that in the man's bedroom. In the work niche, according to information in Adolf Meyer's book, there was a carpet by Gunta Stölzl. The telephone was a typical 1920s hand-cranked model, which could be used for calls within the house, for which it

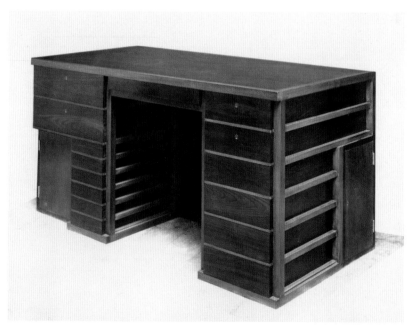

Desk, 1923, design: Marcel Breuer

Work niche, 1923

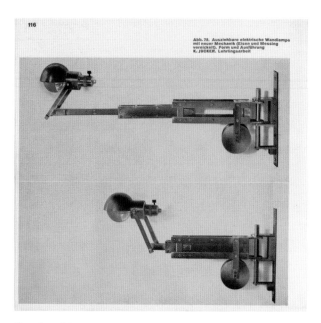

116

Abb. 78. Ausziehbare elektrische Wandlampe
mit neuer Mechanik (Eisen und Messing
vernickelt). Form und Ausführung
K. JUCKER. Lehrlingsarbeit

Electric wall lamp, 1923, design: Carl Jakob Jucker

was connected with an identical telephone in the woman's bedroom, as well as for making external calls.

A lamp by Carl Jakob Jucker was permanently affixed to the wall over the desk. The swivel-mounted model could also be extended forward with a kind of telescope mechanism. Moreover, the head and lighting element could be turned in a vertical direction. The light fitting thus offered the maximum flexibility to direct light wherever it was needed. The lighting element was a light bulb screened from above and in front so that the light did not directly dazzle the user. The electricity supply was connected by means of a cable wound round a roll, which could be lengthened and re-shortened. The design was not yet fully refined, however, and the fitting was an electric shock hazard. As far as is known, Jucker did not continue to experiment with this mechanism afterwards. Instead, the principle of scissor-arm lamps prevailed. ANKE BLÜMM

The man's bedroom

Directly adjacent to the work niche is the man's bedroom. The room is designed as a space for retreat and its movable furnishings consisted of a bed, a table, a chair with textile webbing, probably by Marcel Breuer, and a carpet by Lis Deinhardt from the weaving workshop at the Bauhaus. The black stained oak and reddish padauk woods of the furniture corresponded with the yellow colour used on the walls of the room. The designs for the furniture were by Erich Dieckmann, and it was manufactured in the cabinetmaking workshop at the Bauhaus. The same is true of the full-height built-in cupboard adjacent to the bathroom, which provided the room's only storage space. From the records of the sale of the house, dated 1924, it can be inferred that the furniture ensemble was completed with another side table, although the known pictures have not yielded confirmation of this as yet. Additional shelf space was provided by the plates of opaque glass affixed to the walls. The room is illuminated by a reading lamp integrated into the wall and tubular lamps fitted to the ceiling,

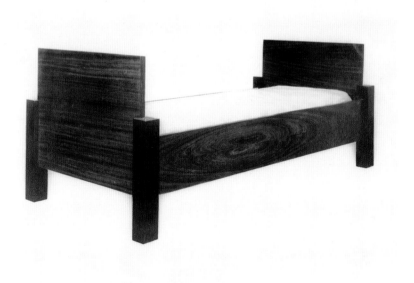

Bed for the man's bedroom, 1923, design: Erich Dieckmann

Man's bedroom, view towards the work niche, 1923

Man's bedroom, view towards the bathroom, 1923

Original reading lamp in the man's bedroom, 2018

which were manufactured in the metal workshop at the Bauhaus from designs by László Moholy-Nagy. Only the original reading lamp has survived. The tubular lamps are from 1999, and the rectangular wooden carcass installed at the same time acts as a placeholder for the lost built-in cupboard. MARTINA ULLRICH

The bathroom

The bathroom is situated between the woman's and the man's rooms. In that era, separate bedrooms in a house of such modest size were a highly unusual and modern idea. Neither was it commonplace to have a bathroom with hot water and a bathtub.

The bathroom was composed of three elements: a washstand, a toilet and a built-in bathtub that doubled as a shower. The bathwater

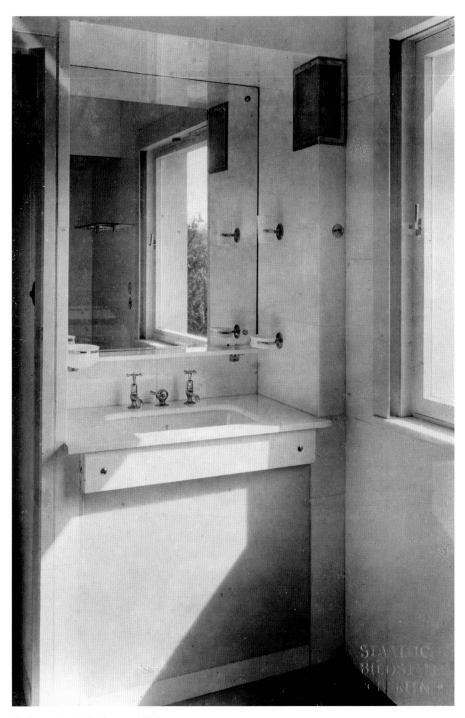

Washstand in the bathroom, 1923

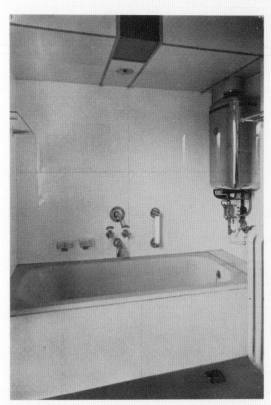

TRITON
WERKE 45
HAMBURG

WANDFLÄCHEN- UND WANNENVERKLEIDUNG AUS ALABASTERGLAS DER DEUTSCHEN
SPIEGELGLAS-A.G. FREDEN AN DER LEINE

EINGEBAUTE WANNE UND GASBADEOFEN IM BAD

Bathroom with shower, bathtub and Junkers gas water heater, 1923

was heated by a Junkers gas water heater. The sanitary fittings and taps were supplied by the Triton-Werke in Hamburg and were advertised as easy-to-clean, jointless, acid-resistant and trimless. The shower was operated with the upper lever of the wall-mounted tap fitting, which also had separate hot and cold taps for filling the bath. Affixed next to these were a grip handle and two storage surfaces in the form of soap dishes. The walls were tiled with white opaque glass supplied by the Kristall-Spiegelglasfabriken.

The rubber floor covering was fitted on a slight incline and had a drain. Over the radiator and on the right beside the window hung a towel rail.

The washstand area was completely clad with white opaque glass and had a central mirror. Hot and cold water could be turned on and off separately with the taps at the wash basin. This had brackets on either side which held white containers for open storage. At the top on the right was a built-in rectangular bathroom light, which was turned on and off with a rotary switch to the right.

Next to the washstand was a toilet room with a separate door. Installed inside was a water closet with a raised cistern.

The rubber flooring has not survived. The taps now replacing the lost originals date from 1998–99. At that time, the intention of the Freundeskreis der Bauhaus-Universität was to return the house to a usable state. The lamp shade above the washbasin is original, as are the metal brackets and the uppermost opaque glass tiles around the washbasin. The missing sections of wall cladding, on the other hand, were replaced in 1999 with white acrylic resin tiles, since no manufacturer of equivalent white opaque glass tiles could be found despite laborious research. ANKE BLÜMM

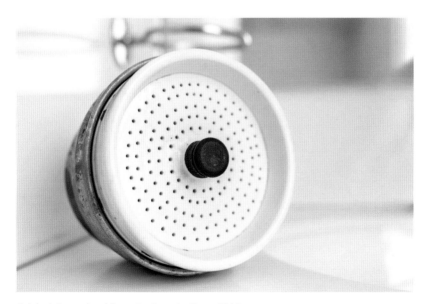

Original shower head from the Haus Am Horn, 2019

The woman's bedroom

The two parents' rooms are connected by a small corridor, the ceiling of which was painted in black. The design of the woman's bedroom shows structural parallels to the man's room: built-in furniture, a bed and a table, a chair and a carpet. In this instance, however, the design was entrusted to other Bauhaus students. The carpet was a work by Agnes Roghé from the Bauhaus weaving workshop. The satinwood and walnut furniture was made in the cabinetmaking workshop to designs by Marcel Breuer. The full-height built-in cupboards and doors were produced by the court cabinetmakers G. & H. Schütze in Berlin. A section of the built-in cupboards is not documented photographically and can only be inferred from a stereometric rendering and the floor plan. The dressing table with its two movable mirrors and matching chair was Marcel Breuer's journeyman's piece. A telephone beside the radiator and a hairdryer and electric curling-iron heater for contemporary hair styling underscored the ambition to equip the house to ultra-modern

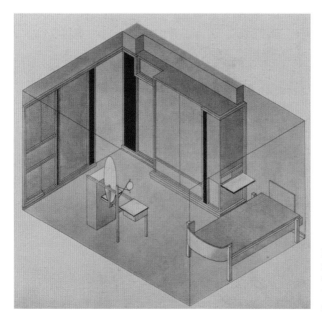

Isometric rendering of the woman's bedroom, 1923, drawing: Marcel Breuer

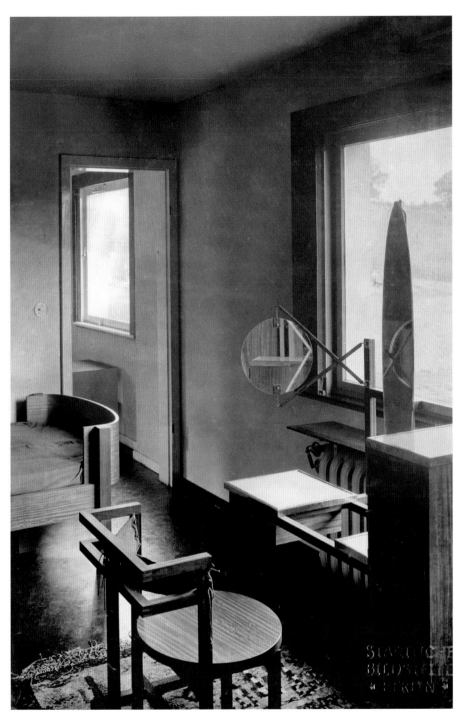

Woman's bedroom, 1923

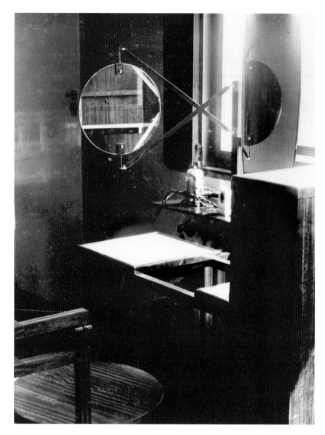

Detail with
hairdryer
and electric
curling iron
heater, 1923

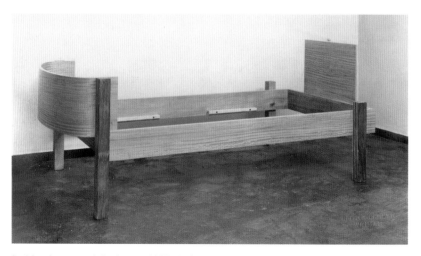

Bed for the woman's bedroom, 1922, design: Marcel Breuer

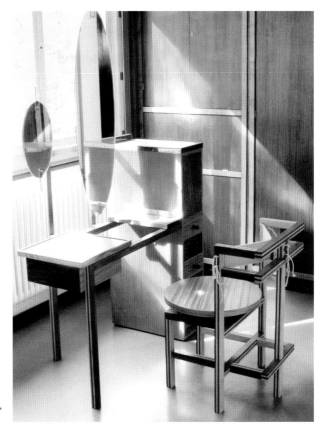

Dressing table and chair, installation in the Haus Am Horn, 2004, design: Marcel Breuer, 1923, partial reconstruction: Gerhard Oschmann, 2004

standards. The walls themselves were painted in grey, off-white and bright yellow.

The original lighting in the woman's room is not seen in the historical pictures. The wall cupboards were reconstructed in 1999. The dressing table survived in rudimentary form and is held today by the Stiftung Bauhaus Dessau (Bauhaus Dessau Foundation). In 2004 it was partially reconstructed – like the living room cabinet – by the architect Gerhard Oschmann. The version on display in the woman's bedroom today is a subsequent reconstruction by Oschmann from 2018–19. MARTINA ULLRICH

The children's room

The children's room is directly adjacent to the woman's bedroom and contains the only additional door into the garden. It was intended to provide the children with 'the most beneficial and healthy surroundings possible'. After the central living room, it is the second largest room in the house. It was furnished according to designs by Alma Buscher and Erich Brendel, and with a carpet by Benita Otte. Especially prominent was the toy cabinet, the elements of which also included six play blocks, a chest and a chair with wheels. Not only did the cabinet provide storage space for the children's toys, but when opened up it could also be used as a puppet theatre. In the historical photos, a construction toy designed by Alma Buscher, known as the 'shipbuilding game', can also be seen.

Up to the height of this cabinet, the walls of the room are clad with one red, one blue and one yellow wooden chalkboard, which were designed as writing and painting surfaces. The lighting for this part of the room was supplied by a lightbulb mounted behind a circular disc of matt plate glass. The room was additionally equipped – as was the guest room – with a washstand complete with mirror and running hot water.

Across from the washstand was probably also a children's bed and a baby-changing dresser or another built-in cupboard; at least this is suggested by the floor plan and the records of sale. There is not sufficient evidence in the historical photographs to be certain. So far only shots showing a reproduction of the interior of the children's room, dating from 1924, give an idea of how the missing items might have looked. These were made for the congress of the Berufsorganisation der Kindergärtnerinnen, Hortnerinnen und Jugendleiterinnen Deutschlands (Professional organisation of kindergarten, childcare and youth workers in Germany) and were exhibited in a Jena kindergarten.

The ceiling light was partly reconstructed in 1999 and full reproductions made of the tubular lamps over the washstand. A later version of the toy cabinet dating from 1924 has survived and was successfully purchased by the Klassik Stiftung in 2012. It can be seen

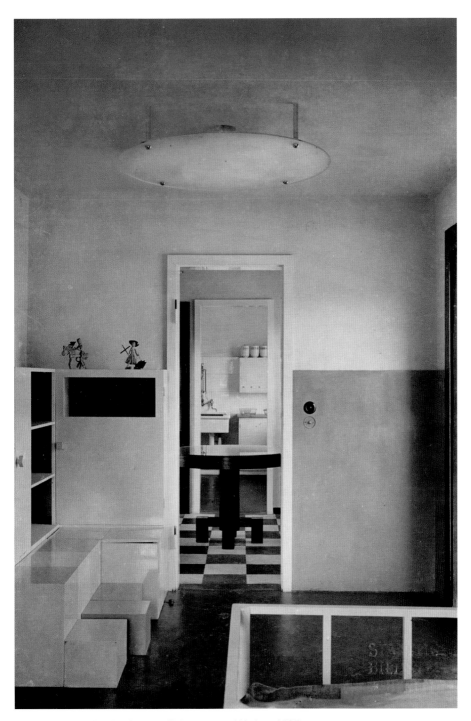

Children's room with view into the dining room and kitchen, 1923

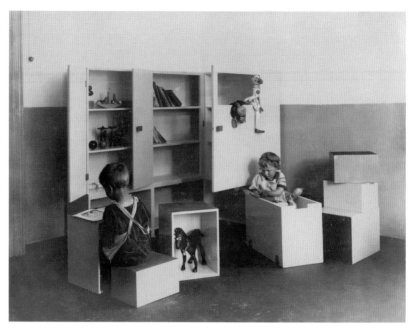

Toy cabinet for the children's room with two children playing, 1923

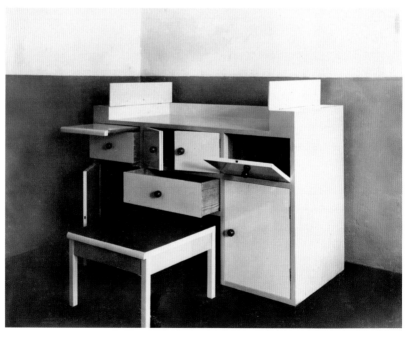

Changing table with linen closet, 1924

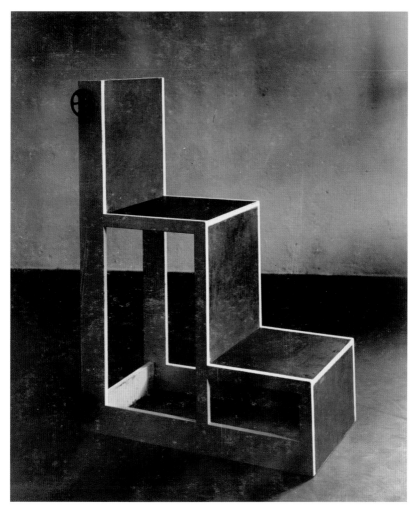

Chair with wheels for the children's room, 1923

in the 'New Everyday Life' section of the Bauhaus Museum. The
reproduction exhibited in the room today was made in 2018–19. A
definitive first layer of paint that would confirm this room's original
wall colour has not yet been identified. MARTINA ULLRICH

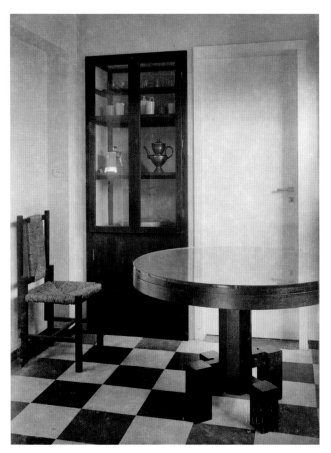

Dining room with built-in cupboard, 1923

The dining room

The dining room connects the children's room with the kitchen. The layout aimed at making it possible to work in the kitchen while keeping an eye on the playing children. At the same time the room was separated from the kitchen, which shielded it from cooking smells. The room itself was intended for the sole purpose of eating together. Hence it was furnished functionally with a built-in cupboard, a table and four chairs. A glass plate was fitted to the table to protect its surface. The furniture was designed by Erich Dieckmann and made in the joinery workshop at the Bauhaus. Mainly stained in

View of the dining room looking through to the kitchen, 2019

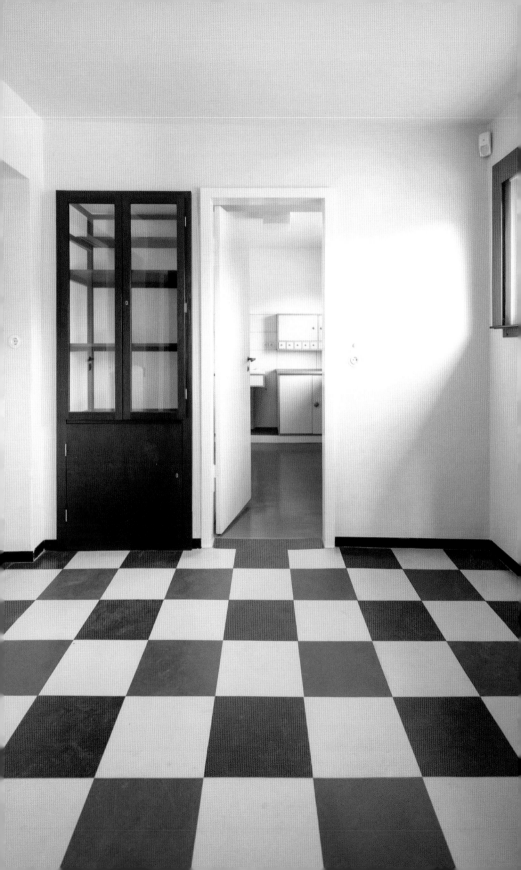

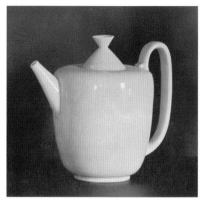

Light fitting in the dining room, 1923 Teapot L19, 1923, design: Otto Lindig

grey and black, the furniture conspicuously contrasted with the red, blue and white mosaic floor covering made of rubber.

The built-in cupboard took the place of the sideboard typical at the time and was designed above all as storage for tableware. The integration of the very latest technological advances into everyday life was underlined here by the toaster and by the tableware made from Jena glass. The ceramic vessels on display came from the pottery workshop at the Bauhaus. The dining room's square light fitting made from matt and metallised crystal plate glass corresponds with the tiled pattern of the floor covering.

The light fitting was reconstructed in 1999, as was the flooring. The built-in cupboard is one of the house's few surviving original furnishings, as indeed are the three wooden windows. It was possible to verify the ochre-reddish tone of the wall colour as the original layer of paint. MARTINA ULLRICH

The kitchen

In 1921, *The New Housekeeping* (1913) by the American author Christine Frederick, one of the very early treatments of functional kitchen design, was published in German as *Die rationelle Haushaltsführung*. It can be assumed that this publication must have been familiar to Benita Otte and Ernst Gebhardt, who were responsible for designing the kitchen in the Haus Am Horn. They designed a 'housewife's laboratory', which can claim to be one of Germany's first built-in kitchens – even pre-dating the well-known 'Frankfurt kitchen' (1926). At the Haus Am Horn, for the first time, work sequences were thought through – similar to Frederick – and suitably reflected in the layout of the kitchen furnishings: carrying the groceries into the pantry, rinsing items at the kitchen sink, preparing foods where the lighting is best, cooking and then serving in the separate dining room – each task is done in sequence without

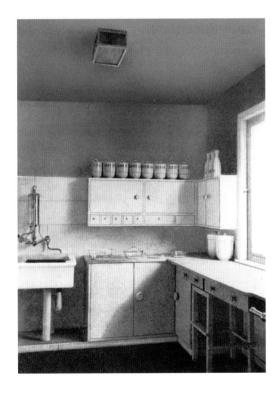

Overall view
of the kitchen,
1923

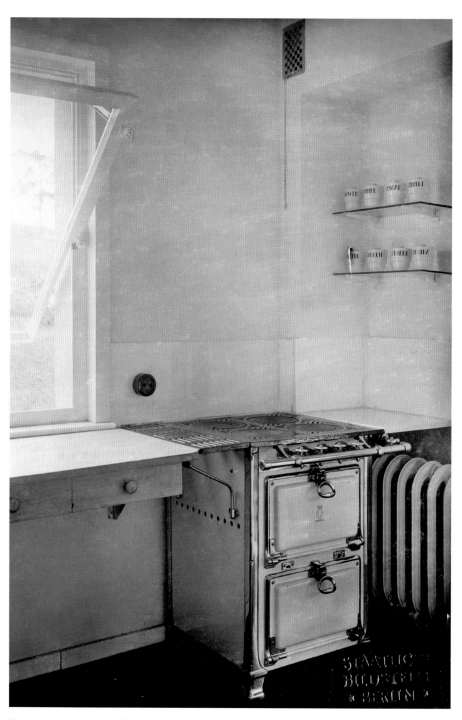

Gas stove in the kitchen, 1923

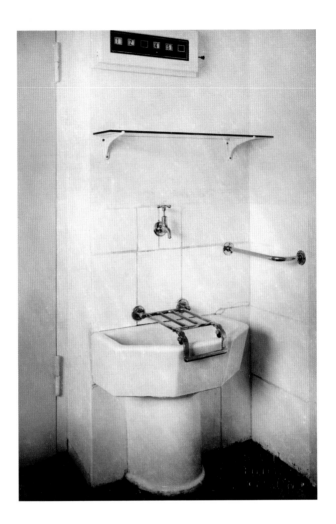

Utility sink in the
kitchen, 1923

unnecessarily walking back and forth. The space-saving work room re-
placed the large kitchen-cum-living-room that was usual in those days.

The kitchen stove was an ultramodern gas roasting and grilling
oven, which could be used without the exertion of transporting wood
or coal. For reasons of hygiene, the walls in the kitchen, as in the
bathroom, were clad with white opaque glass throughout. Also
borrowed from the bathroom was the instant water heater at the sink
cabinet. On the opposite wall there was another separate utility sink
with a clock mounted above it.

The ceramic containers were designed by Theodor Bogler specifically for the Haus Am Horn kitchen and manufactured in series at the Steingutfabriken Velten-Vordamm, a ceramics works near Berlin. Also displayed here in 1923 were the most advanced cooking and baking dishes made in Duraxglas by the Jena firm Schott & Gen. The kitchen itself houses another pantry, which today offers a glimpse into the house's archive of building components.

Today the kitchen is furnished with fitted units dating from 1998, which recreate the system construction principle of the originals. A microwave and a hot water boiler emphasise that this is an updated interpretation with usability in mind. The Bogler containers currently seen on top of the cupboards are new editions. Originals can be viewed at the new Bauhaus Museum. MARTINA ULLRICH

Storage containers, 1923, design: Theodor Bogler, manufacturer: Steingutfabriken Velten-Vordamm

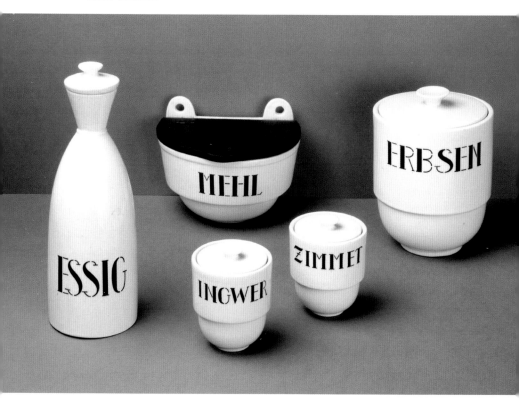

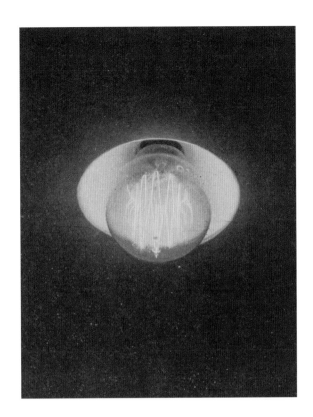

Lamp in the guest
room, 1923

The guest room

Of all the rooms – with the possible exception of the basement – the guest room is the one we know the least about. There are just a few clues about how it was originally furnished. Volume three of the *Bauhausbücher*, about the experimental house and published in 1925, suggests that it had a recess for an electric light in the middle of the ceiling, similar to the one in the toilet room of the bathroom. Otherwise, the floor plan shows that it must have contained at least a bed. According to the sale documents, the guest room also had the same washstand as that in the children's room. Also unique is that, unlike all the other rooms, the guest room has red skirting strips.

The room now serves as the reception and cash desk area, accommodating counters, technical services, storage and a coat rack in an extremely compact space. ANKE BLÜMM

HAUSWÄSCHEREI EINRICHTUNG [63]

J. A. JOHN, AKTIENGESELLSCHAFT ERFURT - ILVERSGEHOFEN
HAUSWÄSCHEREI-EINRICHTUNG MIT GAS-HEIZUNG UND ELEKTRISCHEM ANTRIEB

Mechanisierung der groben Arbeit
75 % Ersparnis an Heiz= und Waschmitteln, an Zeit und Personal
schont die Wäsche

Publicity leaflet for the home laundry facility in the Haus Am Horn, 1925

The basement

A door in the hallway opens onto a narrow staircase leading down to the basement, which was constructed below part of the house. It consists of three rooms: the laundry room, a store room and the boiler room. An advertisement provides a picture of the washing machine, but there is no photographic record of it in situ in the basement. As the laundry system was among the appliances put up for sale in December 1923, it must have found a purchaser. The washing machine was still a very modern appliance at the time and far from being standard equipment for a normal household.

An equally modern and functional innovation was the central heating: it saved having separate stoves in the rooms and hauling wood and coal up from the basement. Instead, the boiler was fuelled only in the basement. There are no pictures of this heating system, just the name of the manufacturer: Johannes Haag, the pioneer of heating systems who had founded his firm in Kaufbeuren in Bavaria in 1843 but then rapidly expanded into capital cities. ANKE BLÜMM

The outdoor spaces

Breathing exercises in the park on the Ilm River, a healthy diet, sun, fresh air and outdoor exercise – these were important elements of community life at the Bauhaus in Weimar. A larger Am Horn site had already been in use since 1920 as a kitchen garden for the Bauhaus canteen. The planning of the outdoor space surrounding the house was therefore an important element from the start.

The present ground area of over 2,000 square metres can be divided up into different zones based on the original site layout: an entrance area, a large meadow on the sides facing the road, and a terraced kitchen garden at the back of the house. Another zone on the south-eastern corner could be interpreted – based on the 1923 architectural plan – as a play area but seems not to have been realised as such. A characteristic feature is the raised terrace zone surrounding the house. A gravelled path ran from the entrance area around the

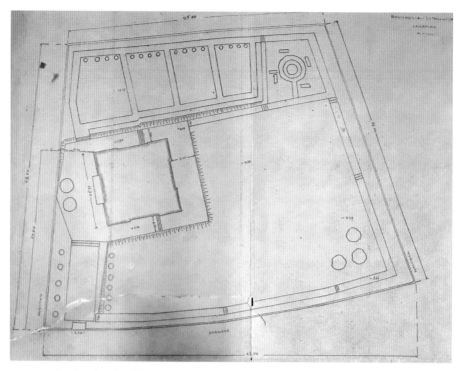

Garden plan, detail from the building application, 1923

site boundary and past the lower section of the kitchen garden back towards the house – for optimal views of the building. Two trees in gateway formation marked the start of this path.

The pathway up to the main entrance of the house was flanked by two rows of dwarf fruit trees. Two ash trees stood opposite the entrance. The path continues on past the house into the kitchen garden at the rear. This area is divided into four different plots separated by paths. These beds were intended for growing herbs, vegetables and fruit.

A notable feature is the black wire fence that encloses the house's outdoor space. It is a pasture-fence patent dating back to the period before the First World War which could be used to span longer widths. None of the original fence has been preserved. In 1999 and 2010 the boundary fence was reconstructed, making use of prefabricated fence elements; the small black plates connecting the

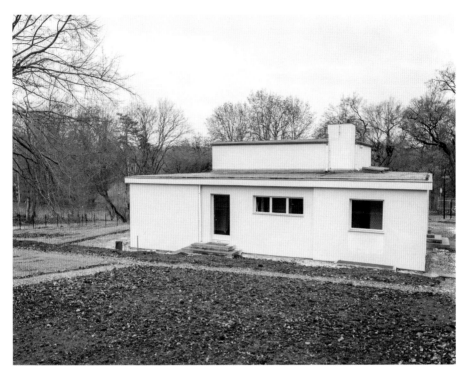

Haus Am Horn viewed from the kitchen garden, 2019

vertical and horizontal wires were glued together. On the side abutting Eduard-Mörike-Strasse an attempt was made in 2018 to replicate the historical technology more closely. The span width was increased, and the small plates were crimped onto the wirework.

The Bauhaus student Rudolf Baschant's treatment of this pasture-fence patent was remarkable. He made use of available technology to create a graphically sophisticated pattern for the entrance gate with the simplest of means. The present-day gate is a reconstruction dating from 1999.

The ideas of being self-sufficient with healthy foods and spending time in the open air were echoed in the garden. The outdoor areas were designed sparingly – most certainly because of the tight time frame. They were nevertheless presentable and in line with the overall programme. ANKE BLÜMM

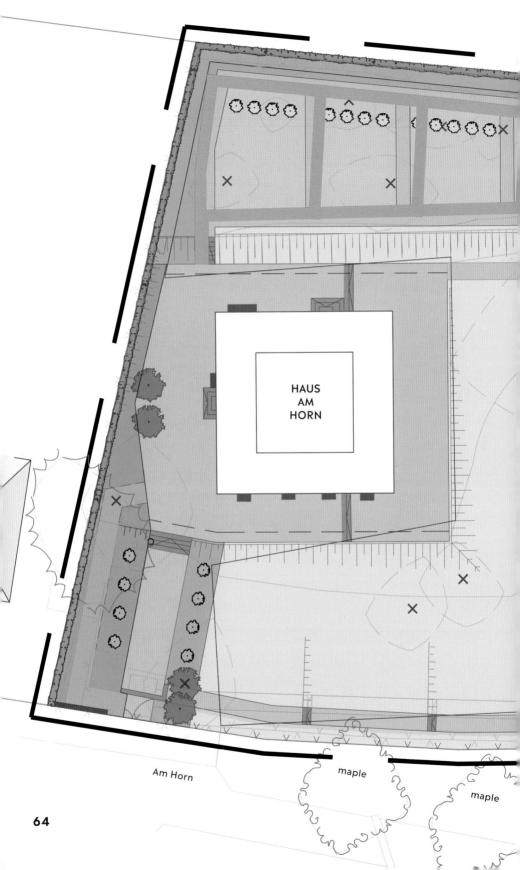

HAUS
AM
HORN

Am Horn

maple

maple

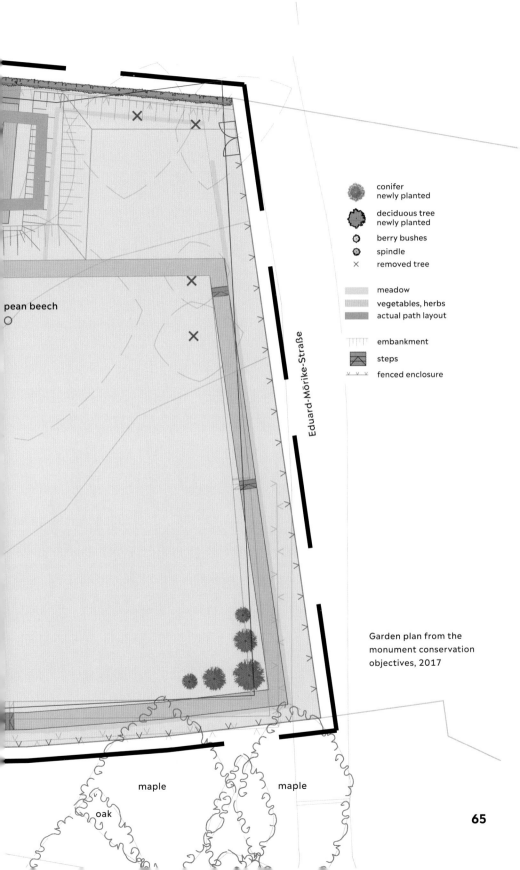

conifer
newly planted

deciduous tree
newly planted

○ berry bushes

◉ spindle

× removed tree

meadow
vegetables, herbs
actual path layout

embankment

steps

fenced enclosure

pean beech

Eduard-Mörike-Straße

Garden plan from the
monument conservation
objectives, 2017

maple

maple

oak

65

THE STATE BAUHAUS IN WEIMAR

ANKE BLÜMM

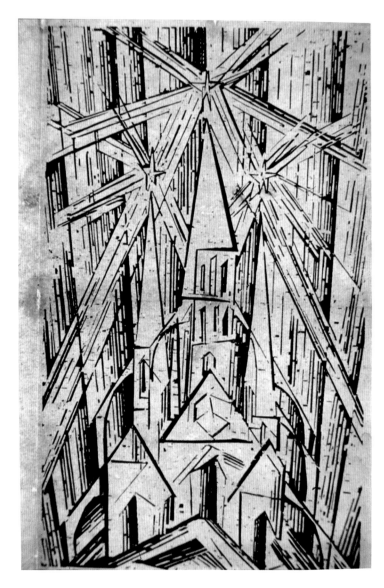

Title page
with cathedral,
Manifesto of the
State Bauhaus in
Weimar, 1919,
design: Lyonel
Feininger

THE STAATLICHE BAUHAUS (State Bauhaus) in Weimar was founded by Walter Gropius in 1919. Without the Bauhaus, the Haus Am Horn in Weimar would have been inconceivable. How did one of the most important art schools of the twentieth century come to be established here, of all places? There had in fact been a long tradition of art education and art patronage in Weimar going back to the mid-nineteenth century. The Neue Museum in Weimar is extensively dedicated to this new departure of modernism and the individuals who drove it.

To establish the Bauhaus, Walter Gropius combined two different Weimar institutions of art education: the Grossherzoglich Sächsische Hochschule für bildende Kunst (Grand Ducal Saxon College of Fine Arts) and the Grossherzoglich Sächsische Kunstgewerbeschule (Grand Ducal Saxon School of Art and Crafts). In doing so, he set the Bauhaus on a path which unified training in the fine arts and the handicrafts and thus created a new type of art school. Students were required to complete an apprenticeship in a craft trade. Every workshop was overseen by both an artist and a master craftsman. Workshops were established for working in metal, textiles, ceramics, joinery and mural painting, among other skills.

Gropius proclaimed the importance of the crafts in his Bauhaus Manifesto of 1919: 'Architects, sculptors, painters, we must all return to the crafts!' Even so, to his mind architecture exerted a guiding influence over all the workshops: their common utopian goal was the community-constructed and -furnished building. The underlying ideal – the medieval masons' guild – is symbolised by the picture of the cathedral on the cover of the Manifesto. Against this backdrop it is clear why the Haus Am Horn, the work of architecture that

Grossherzoglich Sächsische Hochschule für bildende Kunst, later the Bauhaus building, Weimar, 1911, design: Henry van de Velde

the Weimar Bauhaus collectively planned, built and furnished, is so significant to the history of the school; for here the Bauhaus fulfilled its foremost aim, if only on a relatively small scale.

The woodcut on the manifesto's title page is the work of Lyonel Feininger. Feininger was one of the well-known artists whom Gropius succeeded in recruiting as teachers for the Bauhaus in Weimar, as were Gerhard Marcks, Wassily Kandinsky, Paul Klee and Johannes Itten. For all the innovativeness of the Bauhaus and the prominent stature of its teachers, the art school was controversial from the very start and came under constant pressure to justify itself. In 1924 the State of Thuringia cut its funding, forcing the Bauhaus to seek a new home elsewhere. In 1925 the school found a new domicile in Dessau.

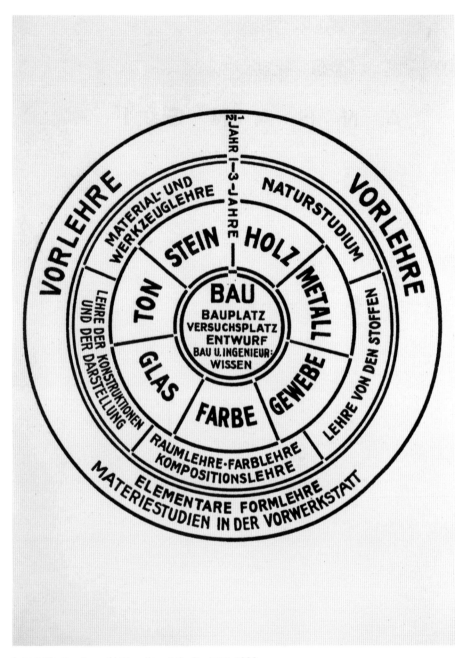

Schematic structure of instruction at the Bauhaus, 1922

EARLY PLANS: THE BAUHAUS HOUSING ESTATE

UTE ACKERMANN

Views and floor plans of the house at Bauhausweg 2, 1920, design: Walter Determann

IN FOUNDING THE STAATLICHE BAUHAUS in Weimar in 1919, Walter Gropius was pursuing plans that were far-reaching in scope. By providing attractive housing and living conditions he hoped to convince artists and intellectuals to relocate to Weimar, at least periodically, and to form a 'republic of minds' that would give rise to a new cultural centre for Germany. The director involved the Bauhaus in the founding of this housing estate from the very start. All its masters and students were called upon to participate in the project by contributing ideas and designs. But the Bauhaus housing estate was more than a design assignment. In accordance with one of the vital founding principles of the Bauhaus, community living and working were seen as a foundation for the reform of life as a whole. Gropius attached importance to creating fundamentally sound conditions of existence for the members of the Bauhaus.

A working group that formed around the *Bauhäusler* Walter Determann presented designs and models for a Bauhaus housing estate as early as the summer semester of 1919 and received an award for the work. A year later, Determann designed another housing estate plan. The complex was stringently symmetrical in structure. The site was enclosed and had towers at the boundaries. Apart from residential, workshop and community buildings, the design includes sports grounds and playgrounds, a stadium, an indoor swimming pool, a gymnasium and an open-air pool.

In 1920 the housing estate site Am Horn was leased to the Bauhaus. Initially it was decided to create accommodation here by erecting temporary cabins built with donated construction timber, but this came to nothing. Part of the site was used as a kitchen garden for growing vegetables, to supply produce for the Bauhaus canteen.

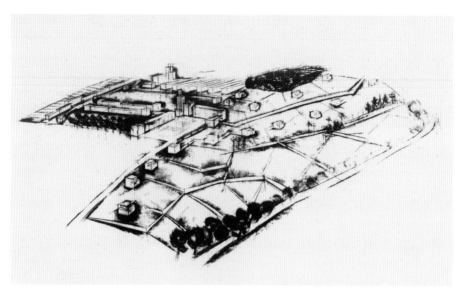

Bauhaus housing estate site, 1922, design: Walter Gropius, Fred Forbát, drawing: Farkas Molnár

Residents already living on Am Horn street mounted a vigorous campaign against the housing estate plans, fearing that 'the all-too-familiar antics and notorious lives of the said students endanger the condition of the park in the splendid birch drift – these jewels of the city of Weimar – in an alarming way.' Such was the wording of a complaint now preserved in the Hauptstaatsarchiv (Main State Archive) in Weimar. The proposed settlement of wooden cabins was also criticised as inappropriate.

The housing estate plan was not forsaken but could not be realised at first. At least on paper, the settlement site grew continuously until 1922. Then in 1923, after the establishment of the Siedlungsgenossenschaft des Bauhauses (Bauhaus housing estate cooperative), the building of the Musterhaus Am Horn (Am Horn model house) took place. The relevant passage in the 1923 exhibition catalogue reads: 'in one of Weimar's most beautiful locations, a housing estate site is being developed on which detached and group houses will be constructed for members and friends of the Bauhaus to live in.'

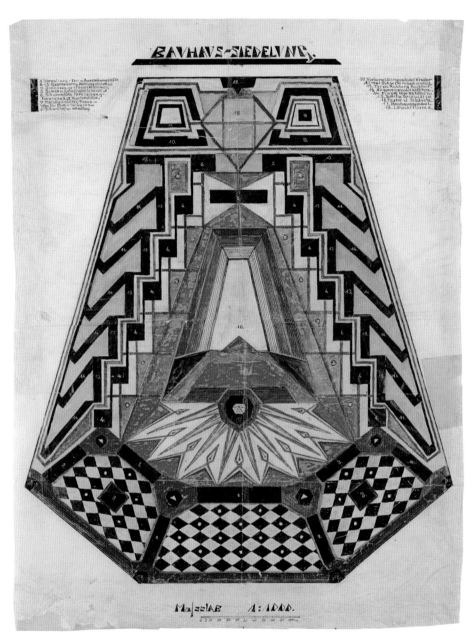

Bauhaus housing estate in Weimar, site plan, scale 1:1000, 1919–20, design: Walter Determann

THE EXHIBITION CONCEPT

INTERVIEW: ANKE BLÜMM WITH CLAUDIA HOFFMANN
AND GERHARD KALHÖFER, KALHÖFER & HOFFMANN
EXHIBITION DESIGN

What was your impression of the house, the first time you went inside?

The building had a very sober effect on us, from both the outside and the inside. We felt that in its empty state, the idea of the house as an experimental house couldn't be conveyed.

What do you consider special about the historic Haus Am Horn?

Its clarity as a type and the abstraction of its appearance is the great achievement. In keeping with the social conditions of the time, an honest and objective formal idiom was developed which we still perceive and refer to as contemporary, even today.

How did you come up with the idea of the 'outline furniture'?

The building and furnishings in their totality embody the Bauhaus idea of a communally designed work of art. The aim is therefore to enable the visitor to envision how the original rooms of the experimental house looked in 1923. The outline furniture is there to suggest the placement of objects that have been lost. The most important exhibit is the Haus Am Horn itself. To avoid distrupting it while meeting the added requirement of staging an exhibition in it, our second step was to integrate the information level of the presentation into the outline furniture.

What will the Haus Am Horn of the future look like?

An epochal experimental house like the Haus Am Horn is no longer conceivable today. Globalisation and digitalisation are already leading to an architectural diversity that offers divergent responses to the complexity of questions facing society. Postmodernism will probably remain the last great architectural movement. We will no longer have long-term directions in the future, but short-lived tendencies.

View from the children's room into the woman's bedroom, digital rendering, 2019,
design: Kalhöfer & Hoffmann

Nevertheless, two important questions could dominate architecture in the future. One will certainly be to address our self-destructive behaviour by means of sustainable building and resource conservation, and the other will utilise the digital revolution to generate hyper-intelligent forms of reactive architectures. Being user-controlled and immediately adaptable to individual preferences, these will culminate in the total emancipation of users in relation to architecture. Instead of the architect, ultimately users will be making all the decisions about housing and living space.

THE HAUS AM HORN AS PART OF THE BAUHAUS EXHIBITION OF 1923

MARTINA ULLRICH

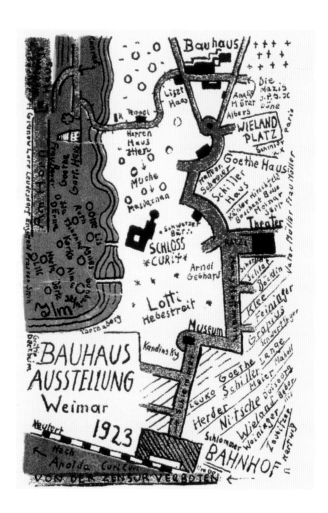

Postcard for the 1923 *Bauhaus-Ausstellung*, no. 19, design: Kurt Schmidt

IN JUNE 1922 the Thuringian State Ministry granted the Staatliche Bauhaus Weimar a loan, although it was bound to the condition that the results of its work hitherto be presented to the public in an exhibition of its achievement. Four months later, on 13 October 1922, an internal appeal within the school declared, from that day forth: 'a state of emergency, which directs the work of every individual and all the workshops towards the idea and form of the exhibition.' Another ten months later, on 15 August 1923, the *Bauhaus-Ausstellung* (Bauhaus Exhibition) was ceremonially opened. A parallel event, Bauhaus week, a five-day arts festival consisting of lectures, concerts, film and theatre performances, also took place. The exhibition route led visitors around the whole of Weimar, stopping at three different points of interest: the then Landesmuseum (State Museum), today's Neues Museum, on Jorge-Semprún-Platz 5; the premises of the Staatliche Bauhaus, today's Bauhaus-Universität; and the edge of the park on the Ilm River, where the experimental Haus Am Horn had been built uphill from Johann Wolfgang von Goethe's Gartenhaus.

Once the decision had been taken, back in September, that the Bauhaus would construct a house of its own as part of the exhibition, in December 1922 the director called for 'participation in [solving] the house problem of the State Bauhaus'. In the experimental house, he exhorted, 'the artist [should contribute] the best form, the engineer the best technology and the business manager the best economy, working in joint and sympathetic alliance towards a beautiful, unified whole'.

Achieving this 'unified whole' through intensive cooperation was entirely in keeping with the change of course proclaimed by Walter Gropius on the occasion of the opening of the Bauhaus exhibition: 'Art and technology – a new unity'. After just three years, this amounted to a decision to abandon the primacy of the crafts. By now Gropius had come to place the school's main emphasis on machines and on cooperation with industry.

All the workshops at the Bauhaus cooperated in the realisation of the building project. Various industries played their part by supplying the very latest materials for the construction and furnishing of the house so that it would represent the technological state of the art. Particularly in the era of hyperinflation, this was no easy undertaking, as is evident from letters sent in January 1923 to American entrepreneurs like Henry Ford and John D. Rockefeller. However, these pleas to financially support the construction of the 'exemplary residential house' proved in vain. Ultimately, the building contractor and Bauhaus patron Adolf Sommerfeld agreed to cover the building costs. By way of additional help, some of the firms involved on site carried out their work at cost price or – as was the case for the gas oven in the kitchen – provided their products as demonstration items only, requiring them to be returned at the end of the exhibition if they had not found buyers.

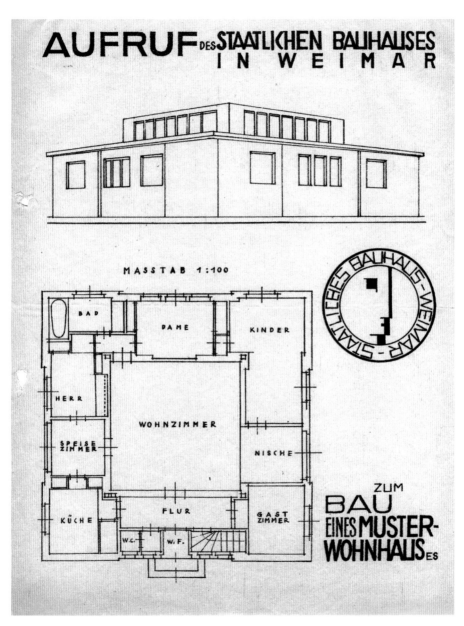

AUFRUF DES STAATLICHEN BAUHAUSES IN WEIMAR

MASSTAB 1:100

BAD

DAME

KINDER

HERR

WOHNZIMMER

SPEISE ZIMMER

NISCHE

KÜCHE

FLUR

GAST ZIMMER

W.C.

W.F.

STAATLICHES BAUHAUS - WEIMAR -

ZUM BAU EINES MUSTER-WOHNHAUSES

Public announcement from the State Bauhaus in Weimar for the construction of a model residential house with first version of the design, 1923

STRUCTURAL DESIGN, CONSTRUCTION AND FURNISHINGS

ANKE BLÜMM

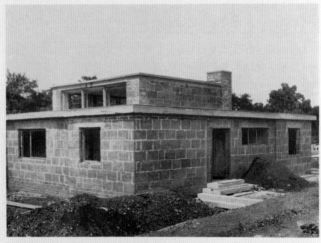

Publicity panel for Jurko blocks, 1925

ON APRIL 11, 1923, the foundation stone was laid for the model house. It had not been designed by an architect but by the youngest Bauhaus master and painter, Georg Muche. He had served as the master of form in the weaving workshop since 1921 and won an internal ballot at the school with his proposal.

Muche's design incorporated aspects of Gropius's construction-kit principle and designs by Fred Forbát. Forbát was a Hungarian who had previously trained as an architect and started out as an employee in Gropius's architecture office. On behalf of the Bauhaussiedlung GmbH (Bauhaus housing estate limited liability company), from 1922 he worked intensively on the development of the Bauhaus housing estate site. He designed modular building sections which could be assembled – depending on the residents' requirements – into different house types. A hallmark of this project was a core living room adjoined by smaller rooms on three sides. Muche refined this idea into a square floor plan with functional rooms all the way round. The newly married Muche took the role of the housewife in particular into consideration. Her work should be reduced to a minimum 'so that she can devote herself to intellectual tasks again'.

Adolf Meyer and Walter March from Walter Gropius's architecture office were entrusted with the management of the construction work. The Bauhaus was necessarily dependent on this vital professional support because, for organisational and financial reasons, there was still no architecture class at the Bauhaus itself. Only from 1927 onwards, at the Dessau Bauhaus, was a regular architects' training programme introduced. This is one of the frequently cited contradictions between reality and the programmatic aspirations of the early Bauhaus.

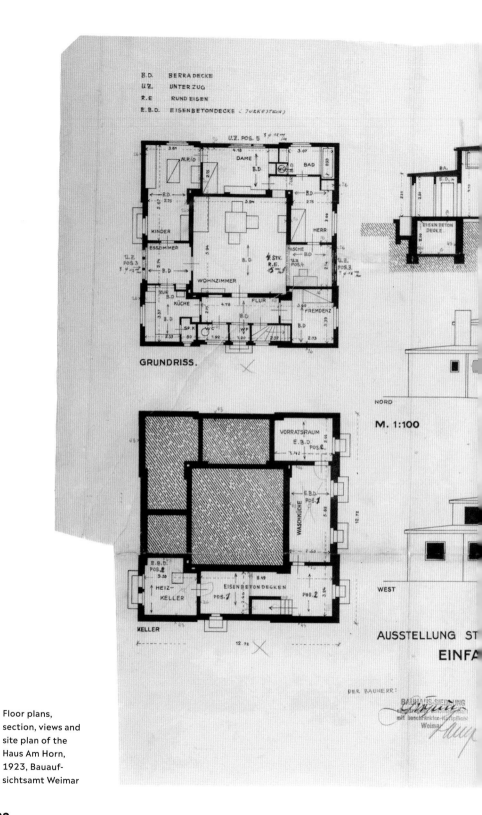

Floor plans, section, views and site plan of the Haus Am Horn, 1923, Bauaufsichtsamt Weimar

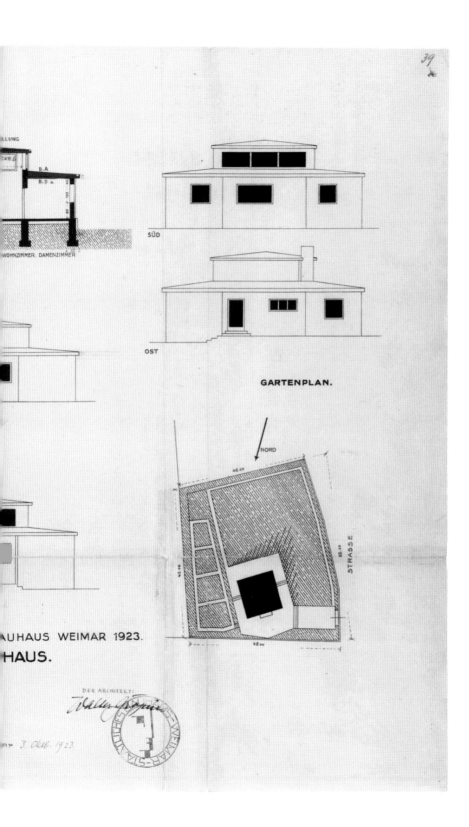

SÜD

OST

GARTENPLAN.

NORD

STRASSE

AUHAUS WEIMAR 1923.

HAUS.

DER ARCHITEKT:

3. Okt. 1923.

WOHNZIMMER. DAMENZIMMER

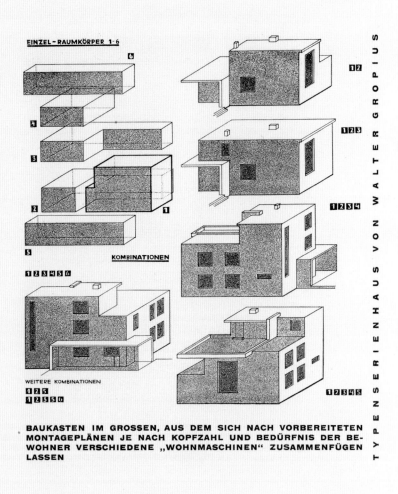

Large-scale construction kit, serial house type, 1922–23, design: Fred Forbát, Walter Gropius

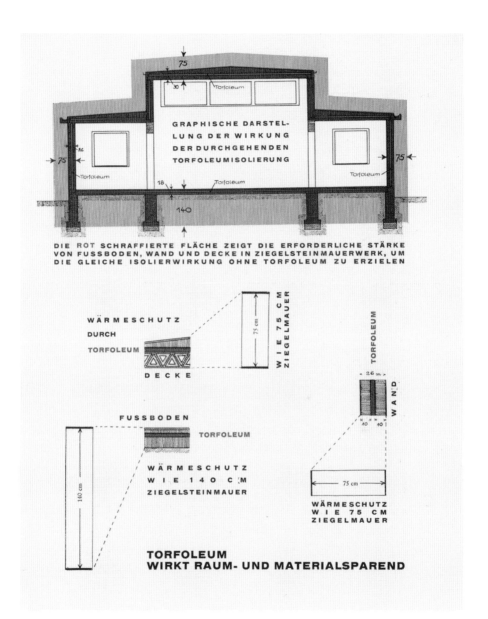

Publicity panel for Torfoleum, 1925

The fundamental idea, in those times of economic hardship and housing scarcity, consisted in enabling a family of three to four people to lead an autonomous, affordable, community-based family life in a home conforming to the most modern standards. After a construction period lasting just four months, the house was finished. The Soziale Bauhütte Weimar (Weimar social builders' guild), a trade union building organisation, carried out the building work.

The experimental construction was carried out using Jurko lightweight concrete blocks. The use of this modern building material promised various advantages, such as saving working time due to the larger construction blocks and reducing the thickness of walls while simultaneously improving the building's physical properties. Added to this was an innovative thermal protection concept based on insulation with 'Torfoleum', an industrially processed material manufactured from peat. Its insulating properties still bear comparison with present-day materials. A similarly well-thought-out technique was the use of triangular Berra hollow bricks, which yielded great stability whilst economising on concrete when used in a staggered formation. The third Bauhaus book, *Ein Versuchshaus des Bauhauses in Weimar* (An experimental house by the Bauhaus in Weimar), published 1925, lists a total of over 40 suppliers, distributors, large contracted firms and medium-sized crafts and trades enterprises. Likewise, the furniture manufactured by the Bauhaus workshops and featured in the house was closely coordinated with the building's design. Nineteen Bauhaus students were mentioned by name as contributors.

The house itself was not merely an exhibit, it was also an exhibition space. The most progressive technology was integrated into the house and thereby showcased: mains electricity in every room, running hot water, central heating, a washing machine, and various new domestic appliances such as a hairdryer, a toaster, a vacuum cleaner, a kettle and a coffee machine. Such evidence clearly identifies the Haus Am Horn as part of a highly dynamic trend which originated with industrialisation in the second half of the nineteenth century and had resulted in sweeping technological progress in daily life. This evolution of materials, furnishings and appliances is exemplified in the 'New Everyday Life' section of the Bauhaus Museum.

BAUHAUS WERKSTÄTTEN[65]

**ALLE WERKSTÄTTEN HABEN BEI DER EINRICH-
TUNG DES VERSUCHSHAUSES MITGEWIRKT:**

STEINBILDHAUEREI

JOS. HARTWIG · HAUSMODELL

TISCHLEREI

MARCEL BREUER · WOHN- UND DAMENZIMMER

ALMA BUSCHER U. ERICH BRENDEL · KINDERZIMMER

ERICH DIECKMANN · SPEISE- UND HERRENZIMMER

BENITA OTTE U. ERNST GEBHARDT · KÜCHE

METALLWERKSTATT

ALMA BUSCHER · BELEUCHTUNG IM KINDERZIMMER

C. J. JUCKER · SCHREIBTISCHLAMPEN

JULIUS PAP · STEHLAMPE IM WOHNRAUM

WANDMALEREI

ALFRED ARNDT U. JOSEPH MALTAN · AUSMALUNG DER INNENRÄUME

WEBEREI

LIS DEINHARDT · TEPPICH IM HERRENZIMMER

MARTHA ERPS · TEPPICH IM WOHNZIMMER

BENITA OTTE · TEPPICH IM KINDERZIMMER

AGNES ROGHÉ · TEPPICH IM DAMENZIMMER

GUNTE STÖLZEL · TEPPICH WOHNZIMMERNISCHE

KERAMISCHE WERKSTATT

THEO BOGLER UND OTTO LINDIG · KERAMISCHE GEFÄSSE

5

Participating students from the Bauhaus workshops, 1925

ON THE RECONSTRUCTION OF THE BREUER FURNITURE

INTERVIEW: ANKE BLÜMM WITH GERHARD OSCHMANN, ARCHITECT

What led you to get involved with the Bauhaus furniture?

I began studying for my architecture degree in Weimar in 1962. One of my teachers, Peter Keler, was a former Bauhaus student. So even back then, I started to take a strong interest in the Bauhaus and particularly in Bauhaus furniture designs. One of my friends, Klaus-Jürgen Winkler, later became a professor of architecture in Weimar. In the course of many conversations with him and others, we hatched the project around 1999 to reconstruct Walter Gropius's director's office in what is now the Bauhaus-Universität.

How did the cooperation with the Bauhaus Dessau Foundation come about?

In connection with the reconstruction of the Gropius room, I studied Gropius's desk in great detail. At the time, the Bauhaus Dessau Foundation had already commissioned a reconstruction. Together we came to the conclusion that certain details still needed to be optimised. On the basis of this productive exchange, the foundation approached me when two original pieces of furniture by Marcel Breuer from the Haus Am Horn came into its possession.

How did this original furniture survive at all?

It was a spectacular discovery that these pieces of furniture still existed! After all, the financier of the Haus am Horn, Adolf Sommerfeld, had had all the movable furnishings transported to Berlin in 1923. As compensation for services rendered, Sommerfeld gave these two furniture items to the landscape architect Marta Beer-Barley, who was very devoted to Neues Bauen (New Building). Down that line, the furniture was preserved in Berlin, albeit in damaged and incomplete condition. I was then commissioned with restoring the original parts and reconstructing the missing elements.

Living room cabinet, 1923, design: Marcel Breuer

What do you say to critics who think the reconstruction of such furniture cannot be justified?

Each piece of Marcel Breuer furniture is endowed with immense finesse and quality. Coming to grips with them and studying them in detail was a major challenge, but also a very valuable experience. It is important to have reconstructed both pieces of furniture once again as exhibition pieces to be placed in their original setting, so that visitors can see Breuer's subtly displayed craft skills for themselves.

THE RECEPTION OF THE HAUS AM HORN

ANKE BLÜMM

Internationale Architektur exhibition, part of the *Bauhaus-Ausstellung* of 1923. Plans for the Am Horn housing estate (background) and model of the Haus Am Horn (foreground)

IN THE BAUHAUS-AUSSTELLUNG of 1923, Walter Gropius assertively placed the Haus Am Horn in the context of contemporary architecture in its most modern manifestations: the roundup of international architecture displayed in one room of the Bauhaus building was one of the three sections of the Bauhaus exhibition. A model of the Haus Am Horn, together with the plans for the Bauhaus housing estate, took their place among the latest and most renowned examples from the Netherlands, France, Russia, Germany and the United States.

The contemporaneous press carried extensive reviews and discussions of the 1923 Bauhaus exhibition. The Haus Am Horn – like other elements of the show – attracted considerable attention as a practical demonstration of Bauhaus theory. A selection of these comments from the press is compiled in Magdalena Droste's 1980 monograph on Georg Muche. Overall the critics were divided, with equally strong reactions on either side: from effusive praise for the forward-looking experiment to an anonymous polemical settling of scores. The strange look of the house's exterior was characterised with epithets ranging from 'a house for Martians', 'a North Pole station' or a 'public latrine' to a 'well-solved arithmetic problem' and a 'white chocolate box'.

Descriptions of the interior decor were similarly polarised. There was praise for the practical built-in cabinets, the delicate colours of the wall treatments and the meticulous design of the furnishings and fittings. Comment was passed in equal measure on the emptiness of the rooms without pictures on the walls. While this reduction was enthusiastically welcomed by some, others found it cold and sterile. The architecture critic Sigfried Giedion observed

how much the machine had inspired the design: 'The ideal of form behind the lights, houses and utility objects is the machine. It is good that here, for once, people are attempting to let the substance of the machine inspire them. Tall standard lamps made from iron and glass tubes, pitiless, unmuted by silken shades, put one in mind of laboratory equipment; seats look like weaving looms, furnishings like printing presses, teapots like water-gauge glasses.' Here he appeared to be referring directly to the standard lamp by Gyula Pap and the *Slatted Chair* by Marcel Breuer. Other critics, too, were inspired by Breuer's chairs. While they were 'strangely constructed from slats and belts', remarked one journalist from the *Allgemeiner Anzeiger Erfurt*, they proved to be very comfortable – and thus he urged open-minded experimentation with things that initially seemed alien.

Some authors pointed out contradictions: as a detached single-family dwelling, it was anything but an exemplary show house or a low-cost model: the equipment shown was, in reality, only affordable for rich people, they stated, and the layout was too inflexible – which were accurate observations of the Haus Am Horn's inconsistencies.

Models of serial houses, 1922–23, design: Walter Gropius, Fred Forbát

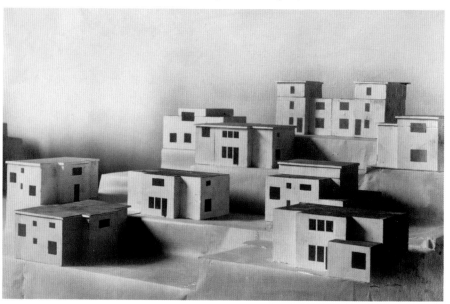

FRANKFURTER ZEITUNG
1. MORGENBLATT
EIN HAUS DAS SEHNSUCHT WECKT
Von Fritz Wichert (Frankfurt)
10. X. 1923

● In der Bauhaus-Ausstellung in Weimar wer-
den die Absichten und Leistungen der neuen
Schule dargetan. Sie läßt sich nicht beschrei-
ben. Auch Leute, die sonst den Pfadfindern
gern beizuspringen pflegen, stehen ihr ratlos
gegenüber und bezeichnen die ausgestellten
Gebilde — vielleicht mit Ausnahme einiger
Arbeiten der Weber und Töpfer — als anti-
bürgerliches Hirngespinnst oder romantische,
das heißt abseitige Gestaltungslaune. Von dieser
Ausstellung soll auch nicht mehr die Rede
sein. Es ist da aber, jenseits vom Park an der
Ilm, am sogenannten Horn, ein Musterwohn-
haus entstanden, und dieses Muster- oder
Probewohnhaus gibt dem Zukunftsbetrachter
aus Neigung und Leidenschaft so viel zu füh-
len und zu denken, daß es sich lohnt, dafür
die Feder in Bewegung zu setzen.

Fritz Wichert, 'Ein Haus, das Sehnsucht weckt' (A house that kindles desire),
Frankfurter Zeitung, 10 Oct. 1923

Nevertheless, certain items of furniture and interior decor ideas
evidently fulfilled their purpose, judging from Konrad Weichberger's
account in the *Bremer Nachrichten* of a child blissfully immersed
in exploring Alma Buscher's toy cabinet. Neither did the aim of
lightening the load of the woman of the house go unnoticed, as the
Dutch journalist Augusta de Wit overheard on her visit to the
exhibition: 'Madam can lie on the sofa and read or, for all I know, sit
at her easel and daub. – The housework is done, after all. Such a
building style is the ruin of the German housewife!' Yet all the
criticism of details and shortcomings was outweighed by the recog-
nition that, as a creation, the Haus Am Horn amounted to something
remarkably new.

HISTORY OF USE AND MODIFICATION, 1923-1998

ANKE BLÜMM

For Sale notice, *Berliner Tageblatt und Handelszeitung*, 19 Dec. 1923

AFTER THE BAUHAUS EXHIBITION, the house initially stood empty. It belonged to the building contractor Adolf Sommerfeld, as compensation for his financial support. He had banked on the calculation that his investment would sell for a higher price later, but in the midst of hyperinflation this failed to come good. In December 1923 the house was touted in a newspaper advertisement as a 'Christmas present', initially inclusive of all the interior fittings and furnishings, but to no avail. Sommerfeld thereupon had all the movable furnishings delivered to Berlin, to meet a destiny that is still an unresolved enigma today.

It was not until September of the following year that he clinched a sale: the home was bought by the notary Friedrich Alfred Kühn. The house built by the Bauhaus community thus became the private property of a non-aficionado. Kühn commissioned three phases of alterations, in 1926, 1927 and 1933: first, an additional door to the garden via a veranda on the south side; second, a porch and altered access to the basement on the entrance side, and finally an extension of the dining room and the children's room to the east, adding an extra room to each. A terrace was created to the south side next to the veranda. It is worth noting that the alterations respected the character of the house and were designed by the architect Ernst Flemming entirely in keeping with the original principle of extensibility. This was the cubature of the building as it existed up to 1998.

After buying the house, Kühn also had the garden layout comprehensively rearranged, with new paths, beds and planting to create more secluded places of privacy on the open site.

In 1938 he sold the dwelling to the Deutsche Arbeitsfront (DAF; German Labour Front), an organisation of the National Socialist

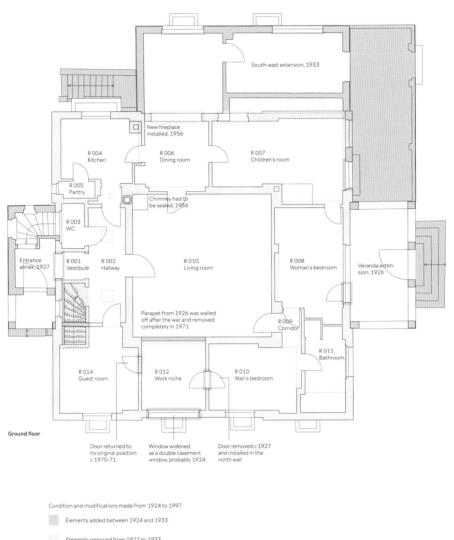

South-east extension, 1933

New fireplace installed, 1956

R 004
Kitchen

R 006
Dining room

R 007
Children's room

R 005
Pantry

Chimney had to be sealed, 1956

R 003
WC

Entrance annex, 1927

R 001
Vestibule

R 002
Hallway

R 010
Living room

R 008
Woman's bedroom

Veranda extension, 1926

Parapet from 1926 was walled off after the war and removed completely in 1971

R 009
Corridor

R 011
Bathroom

R 014
Guest room

R 012
Work niche

R 010
Man's bedroom

Ground floor

Door returned to its original position c.1970-71

Window widened as a double casement window, probably 1924

Door removed c.1927 and installed in the north wall

Condition and modifications made from 1924 to 1997

Elements added between 1924 and 1933

Elements removed from 1927 to 1933

Elements added after 1933

1924–97 structural condition and changes, plan from the monument conservation objectives, 2016

Living room with exhibition vitrine, 1983–98

regime. The house was scheduled for demolition because the Nazis had large-scale plans for the whole of the site. These building plans were thwarted by the outbreak of war, however, and an officer in the German army became an interim tenant.

Between 1945 and 1951 the house was held in trust by the city of Weimar and was then transferred to the city's *Volkseigentum* ('people's property' owned by the East German state). At times there were up to three sets of tenants living in the dwelling, which led to ongoing modifications to the layout: the wall between the living room and the work niche was completely bricked up, while an opening was created between the guest room and the work niche. The bathroom was used as a kitchen, and a shower was installed in the kitchen pantry. As many as three garages occupied space on the site at various

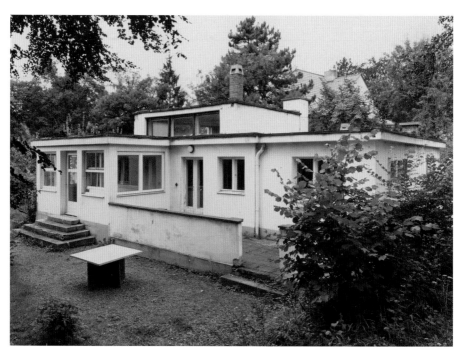

Exterior view of the Haus Am Horn from the south-east with modifications, *c.*1998

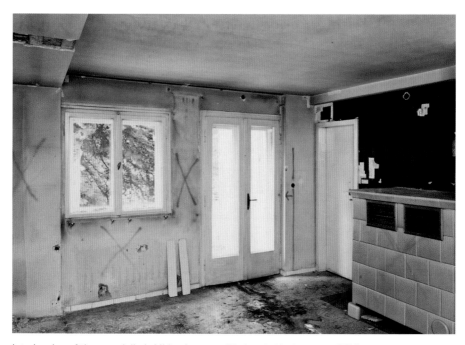

Interior view of the remodelled children's room with door to the terrace, *c.*1998

Reading lamp in the man's bedroom with shelf and books, c.1975

times. From 1971 to 1998 the Grönwald family lived in the house. They were the first to assemble an exhibition about the house, which they displayed in the main living room and opened to the public on a limited basis.

Since 1996 the Haus Am Horn has been listed as a UNESCO World Cultural Heritage site, along with the Weimar art school buildings and the Bauhaus buildings in Dessau. Against this backdrop and paving the way for Weimar's role as European Capital of Culture, in 1999 the Freundeskreis der Bauhaus-Universität Weimar organised the first major renovation programme. Up to 2017 the house was used by the Freundeskreis for a host of exhibitions and events.

THE REFURBISHMENT OF THE HAUS AM HORN

INTERVIEW: ANKE BLÜMM WITH BIRGIT BUSCH, PROJECT CONSERVATOR
FROM THE KLASSIK STIFTUNG WEIMAR, ARCHITECTURAL MONUMENT
CONSERVATION DEPARTMENT

**In what condition did you find the Haus Am Horn at the beginning
of the 2015 refurbishment programme?**
The house had been comprehensively renovated from 1998 to 1999. At
the time a conscious decision had been made to dismantle the exten-
sions added to the building after 1923. Among other works to the inter-
ior, the kitchen had been recreated and some of the built-in furniture and
the lights, including the tubular lamps, had been reconstructed. Since
the aim in 1999 was to return the house to a usable state for exhibitions
and offices, there were a few changes from its original appearance: con-
temporary radiators and double-glazed windows had been installed.
All in all, what we found – understandably enough from the 1990s view-
point – was a compromise of old and new.

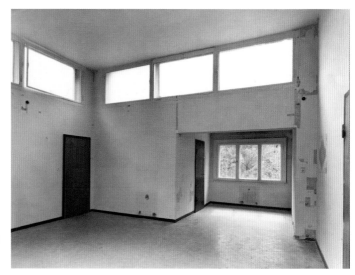

Main room, view
into the work niche
during the renova-
tion, 1998-99

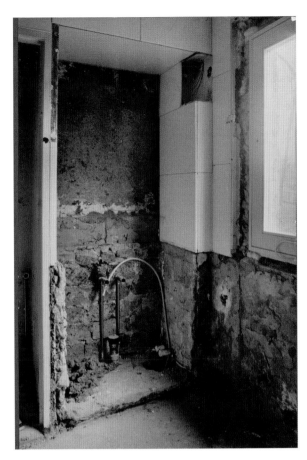

Bathroom during the renovation, 1998-99

How did the work begin?

To start with, defective technological components were repaired or replaced. The most important priority was to draw up monument conservation objectives. An existing set of goals for the outdoor spaces around the house was revised, taking into account the latest research.

What are the overarching criteria that guide your work?

Our aim is to make the exhibition house understandable as a design and technological idea from 1923. This means that we've given up any thought of potentially using the house for offices or rotating exhibitions, because the building itself is the exhibit to be shown. So, to the extent possible, we've worked sensitively to reverse all the disruptive elements that were verifiably added in the 1990s, such as the radiators and the

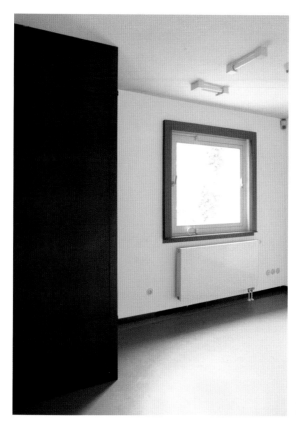

Man's bedroom, view
from bathroom, 2015

double-glazed windows. But we have no ambitions to realise a complete reconstruction of the movable and immovable interior fixtures and fittings.

How do you proceed, in very concrete terms?

Research is always the starting point. Our standard reference is the publication issued by the Bauhaus itself in 1925, Bauhaus book no. 3, on the construction of the house and its interior fittings and equipment. Weighed against the objectives, we then consider which measures are possible, acceptable and necessary for an understanding of the architecture. The majority of measures consist of changing materials and surfaces introduced in 1998 which, in sum, convey a different aesthetic. The windows, being an essential component of the façade and the interior space, have been realised very effectively as reconstructions. When it came to replacing the modern radiators, it was important to obtain

cast-iron models that resemble the contemporaneously built radiators as closely as possible – that is, in the original size and material. Because like almost all the manufacturers from 1923, the original firm no longer exists. We view the present status quo as a process: if historically identical products show up in the next few years, we will consider exchanging what we have now.

How did you handle the outside spaces?

The situation there was similar to the interior: in 1998 work was started on restoring the garden to its original state from 1923, but not all of it could be realised. In resuming this work, we cleared away more of the younger, mostly damaged trees and overgrowth. As a result of that and the reconstruction of the original circular path, the prominent location of the house can be appreciated once again.

Was the entrance ramp also original?

No, obviously not. That is one of the few concessions, so that today we can offer low-barrier access for wheelchair users and pushchairs.

What is it about your work that appeals to you?

It grew more and more enjoyable delving into all the details of the house. For instance, we were missing some sheets of black opaque glass, which were used in 1923 as skirtings, radiator covers and window sills. After a time-consuming search we found a glass supplier with a glassworks in the Czech Republic who could manufacture this special glass. That was a rewarding achievement.

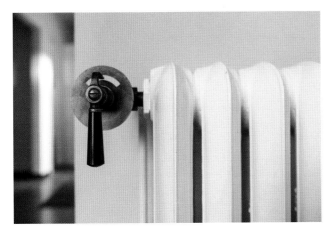

Radiator, 2019

OF TEMPLES AND TECHNOLOGY

The Haus Am Horn in the context of New Building during the Weimar Republic

ANKE BLÜMM

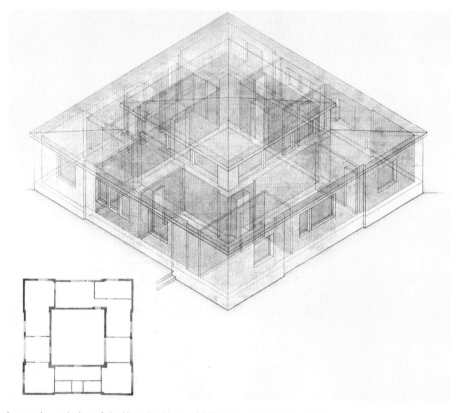

Isometric rendering of the Haus Am Horn, 1923, design: Benita Koch-Otte

THE HAUS AM HORN is part of a broad trend towards the reform of architecture after the First World War. 'Sun, light and air for all!' or 'liberated living' were some typical slogans. New approaches at the end of the 1920s took the form of large-scale housing estates like Bruno Taut's Hufeisensiedlung (Horseshoe Estate) in Berlin or the Neue Frankfurt (New Frankfurt) housing developments headed up by the city architect and planner Ernst May in Frankfurt am Main.

The Haus Am Horn occupies an exceptional position in the context of this movement. For one thing, it can be seen as a very early example of Neues Bauen (New Building) in the Weimar Republic. It was only somewhat later, from the mid-1920s, after the economy had consolidated, that modern forms of architecture and housing began to spread around Germany. That said, Neues Bauen only accounted for five to ten percent of all construction, a comparatively low share. At the time, the use of flat roofs, large glazed surfaces and new steel-and-concrete-based construction methods were still largely perceived as odd. It was not uncommon for the new architecture to be greeted with distaste at the local level, as the Haus Am Horn was.

Moreover, precisely because it came into being at such an early date, the house must be viewed as a hybrid construct of different ideas. In some cases, historical precursors are cited in the research: Roman atrium dwellings, for instance, or the famous Villa Rotonda by the Italian architect Andrea Palladio dating from the end of the sixteenth century. But Georg Muche never commented on these supposed antecedents. In any case, axiality and the symmetry of the square can certainly be read as quotations of symbolic architectural forms. The central inner room is redolent of an intimate, heightened

cult setting, and to some extent it thus represents family life as the 'holiest of holies'. The phrase 'temple of art' crops up in the reviews from time to time.

Hence, while on the one hand the Haus Am Horn was the first symbolic 'unified artwork' by the Bauhaus, on the other hand the orientation of the school had already undergone a marked shift in the four years of its existence. The rallying cry was no longer 'Return to the crafts', but rather, 'Art and technology – a new unity'. A strong sense of this shift is already conveyed by the Haus Am Horn. Its distinctive signature is the systematic use of industrial building materials and the latest in modern domestic technology.

This also resulted in certain inconsistencies, however. Although the building was supposed to be a model for low-cost housing, the meticulously chosen fittings were very much the preserve of the upper middle class. The layout was space-saving and functional in design, but this turned out to make it rather inflexible to use vis-à-vis the personal preferences of those residing there. In particular, the architecture took little advantage of the considerable open space around the house – apart from the front door, the only other access to the garden was in the children's room.

Against this background, we can more fully understand a quote from Adolf Behne, who wrote about the house in the weekly magazine *Die Weltbühne* in 1923: 'It is half luxurious, half primitive; half ideal postulation and half time-bound reality; half craft and half industry; half type and half idyll. – But on none of these counts is it pure and convincing, proving yet again to be a matter of aesthetics on paper.' It might be retorted that today, it is precisely this obdurate quality that lends the house its charm. Its ambiguity as a building is a sign of its complex enmeshment with the most eclectic notions of its era in terms of social progress and the history of ideas – with the result that time and again it gives occasion for fruitful debate.

Postcard for the 1923 *Bauhaus-Ausstellung*, no. 6, design: Gerhard Marcks

SOURCES AND LITERATURE

Sources

Landesarchiv Thüringen – Hauptstaats-archiv Weimar

Holdings: Staatliches Bauhaus Weimar (Viewable online at: http://www.archive-in-thueringen.de/de/findbuch/view/bestand/25055)

Literature

Klassik Stiftung Weimar/Ackermann, Ute, and Ulrike Bestgen (eds), Bauhaus Museum Weimar: The Bauhaus Comes from Weimar (Munich, 2019).

Droste, Magdalena (ed.), Georg Muche: Das künstlerische Werk 1912–1927 (Berlin, 1980).

Föhl, Thomas, Wolfgang Holler and Sabine Walter (eds), Neues Museum Weimar: Van de Velde, Nietzsche and Modernism around 1900 (Munich, 2019).

Freundeskreis der Bauhaus-Universität Weimar (ed.), Haus Am Horn: Rekonstruk-tion einer Utopie (Weimar, 2000).

Gropius, Walter, Internationale Architektur, Bauhausbücher 1 (Munich, 1925).

Jaeggi, Annemarie, Adolf Meyer – der zweite Mann: Ein Architekt im Schatten von Walter Gropius, exh. cat. Bauhaus-Archiv (Berlin, 1994).

Meyer, Adolf, Ein Versuchshaus des Bau-hauses in Weimar, Bauhausbücher 3 (Munich, 1925).

Winkler, Klaus-Jürgen, Die Architektur am Bauhaus in Weimar (Berlin, 1993).

——, Bauhaus-Alben, vol. 1: Vorkurs, Tischlerei, Drechslerei, Holzbildhauerei / The Preliminary Course, the Cabinetmak-ing Workshop, the Wood-Turning Work-shop, the Wood-Carving Workshop; vol. 2: Keramische Werkstatt, Metallwerkstatt / The Ceramic Workshop, the Metal Work-shop; vol. 3: Weberei, Wandmalerei, Glas-malerei, Buchbinderei, Steinbildhauerei / The Weaving Workshop, the Wall-Painting Workshop, the Glass-Painting Workshop, the Bookbinding Workshop, the Stone-Carving Workshop; vol. 4: Bauhausaus-stellung 1923, Haus Am Horn, Architektur, Bühnenwerkstatt, Druckerei / The Bau-haus Exhibition 1923, the Haus am Horn, Architecture, the Stage Workshop, the Printing Workshop (Weimar, 2006).

ACKNOWLEDGEMENTS

We are grateful to the following organisations and individuals for their support of our exhibition:

Bauhaus Universität Weimar, Modernist Archive, Christiane Wolf

Bauhaus-Universität Weimar, Andreas Kästner

Bauhaus Universität Weimar, Bernd Rudolf

Brenne Architekten

Freundeskreis der Bauhaus Universität Weimar

Marlies Grönwald

Ihle Landschaftsarchitekten, Robert Backe

Kummer Lubk + Partner, Markus Sabel

Thomas Müller

Michael Siebenbrodt

Sparkasse Mittelthüringen

Stadt Weimar, Abt. Denkmalschutz/City of Weimar Monument Conservation Unit, Klaus Jestaedt

Stadt Weimar, Amt für Gebäudewirtschaft, Dirk Daube

Stadt Weimar, Bauaufsichtsamt, Kerstin Ritter

Stiftung Bauhaus Dessau/Bauhaus Dessau Foundation, Lutz Schöbe, Steffen Schröter, Sylvia Ziegner

Thüringer Staatskanzlei/State Chancellery of Thuringa, Marita Kasper, Daniela Lasserre

Thuringian State Office for Heritage Management and Archaeology, Uta Schaubs

Jordan Troeller

HAUS AM HORN
Bauhaus Architecture in Weimar
From 18 May 2019

An exhibition organised by the
Klassik Stiftung Weimar
www.klassik-stiftung.de

The renovation measures carried out
between 2015 and 2019 were financed by
the Federal Government Commissioner for
Culture and the Media and the Thuringian
State Chancellery.

Die Beauftragte der Bundesregierung
für Kultur und Medien

Freistaat Staatskanzlei
Thüringen

weimar
Kulturstadt Europas

Support for the Bauhaus Agents
programme provided by

KULTURSTIFTUNG
DES
BUNDES

EXHIBITION

Curators Anke Blümm, Martina Ullrich

Consulting Ute Ackermann, Ulrike Bestgen,
Birgit Busch

Exhibition design Kalhöfer & Hoffmann
Ausstellungsgestaltung, employee Johannes
Haucke

Exhibition graphics Maya Hässig

Media concept Jens Weber, Andreas Wolter
of Mediaarchitecture

Furniture reconstruction Gerhard
Oschmann (dressing table, living room cup-
board), Ole Teubner (games cupboard)

Tactile model Tactile Studio

Education/Bauhaus Agents Regina
Cosenza, Maxie Götze, Johannes Siebler,
Valerie Stephani

Conservation Konrad Katzer, Katharina
Popov-Sellinat

Exhibition installation Olaf Brusdeylins,
Nico Lorenz, Uwe Seeber, Karsten Sigmund,
Mike Tschirschnitz

Organisation and finance Ellen Bierwisch,
Ulrike Bestgen

Public relations Franz Löbling, Timm
Schulze

Marketing Melanie Kleinod, Ulrike Richter,
Manuela Wege

Security Alexander Stelzer

Real estate Matthias Richter

PUBLICATION

Editors Anke Blümm, Martina Ullrich

Authors Ute Ackermann, Anke Blümm, Martina Ullrich

Translation Deborah Shannon, Berlin

Copy-editing/Proofreading Joann Skrypzak-Davidsmeyer, Cologne

Picture editing Heidi Stecker, Leipzig

Project lead, Hirmer Verlag
Kerstin Ludolph

Project management, Hirmer Verlag
Ann-Christin Fürbass

Design and visual editing Peter Grassinger (Hirmer Verlag); Petra Ahke, Berlin

Pre-press Reproline Genceller, Munich

Paper Gardamatt Art

Typeface Chronicle Text, Madera

Printing Westermann Druck, Zwickau

© 2019 Klassik Stiftung Weimar; Hirmer Verlag GmbH, Munich; and the authors
www.hirmerpublishers.com

Cover Haus Am Horn, 2018, photo: Tillmann Franzen

Back cover *Lattenstuhl* (Slatted Chair), 1922, design: Marcel Breuer

Frontispiece The man's room, 2019, photo: Thomas Müller

Pages 6-7 The Haus Am Horn in the primary colours red, yellow and blue, 2016, photo: Claus Bach

Bibliographic information from the German National Library The German National Library registers this publication in the German National Bibliography; detailed bibliographic data is available at www.dnb.de.

All rights reserved. No part of this publication may be reproduced, stored in a retrieval system, or transmitted in any form or by any means, electronic, mechanical, photocopying, recording, or otherwise, without the prior written permission of the publishers.

ISBN 978-3-7774-3276-2 (English edition)
ISBN 978-3-7774-3274-8 (German edition)

Despite our best efforts, it has not always been possible to locate the copyright holders for permission to reproduce the images. Any justified claims in this regard will of course be recompensed under the usual agreements.

IMAGE CREDITS

Berlin Bauhaus-Archiv Berlin: p. 79; Bauhaus-Archiv Berlin (Georg Muche): pp. 2, 16, 20, 22, 23, 29, 35, 38, 39, 41, 45, 49, 52, 53, 55, 56, 75, 79, 82–83, 97, 100; Berliner Tageblatt und Handelszeitung: p. 94; Brenne Architekten, Berlin: pp. 96, 102
Bielefeld Stiftung Bethel (Benita Koch-Otte): pp. 55, 104
Bonn VG Bild-Kunst, Bonn 2019: pp. 26 (Gyula Pap); 30, 84, 92 (Walter Gropius); 66 (Lyonel Feininger); 107 (Gerhard Marcks)
Cologne Kalhöfer & Hoffmann: p. 75
Dessau Stiftung Bauhaus Dessau, Esther Hoyer (photo): p. 27; Gerhard Oschmann (photo): p. 47
Düsseldorf Tillmann Franzen (photo): cover, p. 13
Erfurt Thüringer Tourismus GmbH, Dominik Saure (photo): p. 63
Maria Laach Vereinigung der Benediktiner zu Maria Laach e.V.: p. 58 (Theodor Bogler)
Weimar Archiv Marlis Grönwald: p. 97; Claus Bach (photo): pp. 6–7; Bauaufsichtsamt Weimar: pp. 62, 82–83; Bauhaus-Universität Weimar, Freundeskreis archive: pp. 98 (top, bottom), 100, 101; Bauhaus-Universität Weimar, Archiv der Moderne (AdM): p. 72; Bauhaus-Universität Weimar, AdM, Atelier Eckner (photo): pp. 28, 50 (top, bottom), 51; Bauhaus-Universität Weimar, AdM, Atelier Hüttich-Oemler (photo): pp. 14–15, 24, 34, 37, 46 (bottom), 92; Bauhaus-Universität Weimar, AdM, Continental Photo (photo): p. 46 (top) Bauhaus-Universität Weimar, AdM, Staatliche Bildstelle Berlin (photo): pp. 18, 20, 22, 23, 26, 30, 31, 32, 35, 38, 39, 41, 45, 49, 52, 54 (right), 55, 56, 57, 89, 90; Bauhaus-Universität Weimar, Hochschularchiv, anonymous (photo): p. 99; Ihle-Landschaftsarchitekten, Weimar: pp. 64–65; Klassik Stiftung Weimar: pp. 25, 58, 66, 70, 73, 76, 107; Klassik Stiftung Weimar, Louis Held (photo): p. 68; Adolf Meyer (ed.), *Ein Versuchshaus des Bauhauses in Weimar* (Munich, 1925): pp. 10, 16, 42, 54 (left), 59, 60, 80, 84, 85, 87, 92; Thomas Müller (photo): endpaper, pp. 19, 29, 33, 43, 53, 103; *Staatliches Bauhaus 1919-1923*, catalogue, Atelier Hüttich-Oemler (photo): pp. 36, 44, 69, 104; Staatliches Bauhaus Weimar, *Pressestimmen (Auszüge) für das Staatliche Bauhaus Weimar, 1920-1924* (Weimar, 1924): p. 93; Martina Ullrich (photo): p. 40